IMAGES
of America

ST. CHARLES
LES PETITES CÔTES

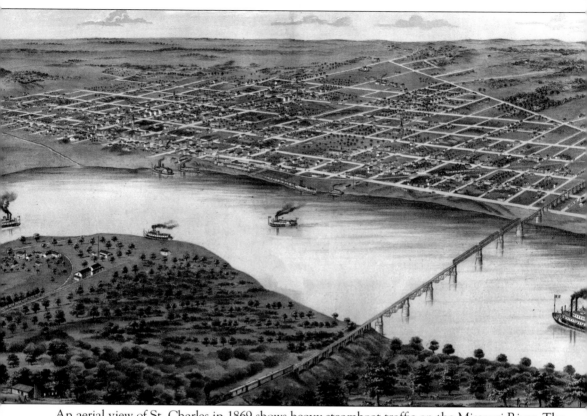

An aerial view of St. Charles in 1869 shows heavy steamboat traffic on the Missouri River. The railroad bridge is also shown, although it was not actually completed until 1871. The sketch is by A. Ruger. (Courtesy of St. Charles County Historical Society.)

IMAGES
of America

ST. CHARLES
LES PETITES CÔTES

Dianna Graveman and Don Graveman
with a foreword from Mayor Patti York

ARCADIA
PUBLISHING

Published by Arcadia Publishing
Charleston, South Carolina

Printed in the United States of America

Library of Congress Catalog Card Number: 2008934416

For all general information contact Arcadia Publishing at:
Telephone 843-853-2070
Fax 843-853-0044
E-mail sales@arcadiapublishing.com
For customer service and orders:
Toll-Free 1-888-313-2665

Visit us on the Internet at www.arcadiapublishing.com

For our children, Stephen, Elizabeth, and Teresa.
Wherever in the world you go, remember whence you came.

CONTENTS

FOREWORD

Mayors get to do some pretty fun things. As mayor of St. Charles, I once got to drive a backhoe for the groundbreaking at a Coca Cola distribution plant, I threw the first fish in the 400-gallon tank when we opened our Bass Pro Shop store, and I even get to be the honorary ringmaster and ride an elephant when the Shriners are in town for their annual circus. To me, though, getting to write the foreword for this wonderful book is an honor I will always cherish.

I have always wanted to be an author. I love books, and I read whenever I get a moment in my busy schedule to put my mind at rest from the regular bustle of the job as mayor. I love photographs even more—photographs that show what the world was like before I got here. This book has it all.

I "arm wrestle" mayors from all across the country over claims to the true place from which Meriwether Lewis and William Clark left to explore the great and glorious Louisiana Purchase—the new frontier to the West. It is true Lewis and Clark rendezvoused here after their long trek across mighty America, passing through large cities, small towns, and the vast countryside that was United States territory. However, I like to explain that it is like when your family goes on vacation. Until the suitcases are packed in the trunk, the house is locked up, the kids are buckled in, and you have hit the open road, you are not really on vacation yet. That is how it was with the expedition. They met up in St. Charles, were welcomed by our townsfolk, purchased their goods, hired their crew, packed their pirogues, and set out to explore unknown territory. The whole town of Les Petites Côtes turned out to see them off and were there when they returned; we have been welcoming—and saying goodbye—to numerous people ever since.

I am excited about this book, which narrates our sometimes colorful, always lively past. Our city's history is rich with characters, flush with happenings, wealthy with lore, and gracious in the appreciation for our heritage. Our town has gone from boom to bust, with thriving and scary times. Yet through it all, our citizens have been the backbone of the community.

The year 2009 sees St. Charles celebrating 200 years as an incorporated city. We look to our past with excitement, because it shows us who we are and where we have been. We celebrate our heritage and look forward to what the future holds for us and our children. This wonderful book lets you share in our past and invites us all to join in predicting our future.

—Mayor Patti York, St. Charles

ACKNOWLEDGMENTS

For advice, assistance with obtaining photographs and information, friendship, and all-around shows of support, we would like to thank the following: Jane Cannon; Gina and Harold Christine; Todd Christine; Mike and Donna Eisenbath; Vicki Erwin; Cleta Flynn; Don and Aggie Graveman; Steve, Beth, and Teresa Graveman; Donna Hafer; Jodi Hendrickson; Ann Hazelwood; Patt Holt; Pam Hummelsheim; Todd Luerding; Sister Anna Mae Marheineke; Barb Musterman; Bruce and Doris Musterman; Orlie Musterman; Jim Rhodes; Joan Runge; Colleen Schaeper; Camille Subramaniam; J. Maurice Thro Jr.; Jan and Will Trogdon; Mayor Patti York; and Patsy Zettler.

Special thanks go to Anna Wilson, acquisitions editor at Arcadia Publishing, and Bill Popp, archivist extraordinaire at St. Charles County Historical Society, for guidance and patience beyond measure.

Unless otherwise noted, all images appear courtesy of the St. Charles County Historical Society.

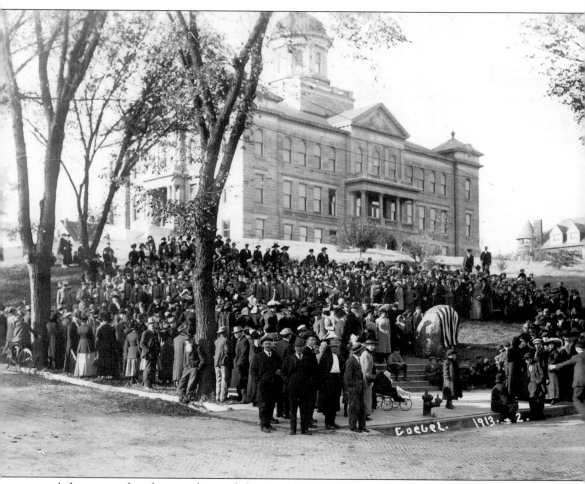

A large crowd gathers in front of the St. Charles County Courthouse in 1913 to dedicate a monument to early explorers and to Boone's Lick Road, out of which grew the Oregon Trail and the Santa Fe Trail. The Daughters of the American Revolution erected the monument, which is covered with a flag of the United States. Rudolph Goebel was the photographer.

INTRODUCTION

The story is told that in 1764, French Canadian Louis Blanchette met French trapper and hunter Bernard Guillet at a quiet spot along the Missouri River in what is today St. Charles. Guillet landed on the river's north bank sometime around 1740 and lived in the area before being taken captive by the Dakota Indians, later marrying into the tribe and becoming chief upon his father-in-law's death. Over the years, Guillet returned many times to the Missouri River, and it was during one of these excursions that he came upon Louis Blanchette. Enticed by the gently rolling hills and plentiful fish and game, Blanchette is said to have asked of his new acquaintance, "When you lived here, did you give a name to your home?"

"I called the place Les Petites Côtes [The Little Hills]," Guillet supposedly replied.

Almost five years later in 1769, Blanchette returned to the wilderness north of the Missouri River with his Pawnee Indian wife and his children to found a permanent settlement in what was then Spanish territory. In 1791, the settlement's people named their first church San Carlos Borromeo for the patron saint of Spain's reigning king, Charles IV. Eventually the village of Les Petites Côtes came to be called San Carlos de la Rio Misuri (St. Charles of the Missouri River).

Because of St. Charles's location on the river and its entrance to the unexplored Western frontier, the town became an important trading center and destination for travelers. Today St. Charles is especially proud of its connection to Meriwether Lewis and William Clark. The famous explorers began their expedition to explore the Louisiana Purchase territory in 1804, right here from the banks of the Missouri River. Along with the Lewis and Clark Boathouse and Nature Center and a larger-than-life statue of the explorers in Riverfront Park, residents and visitors to St. Charles enjoy yearly reenactments and other festivities commemorating the event. Two groups designated as official reenactors by the National Lewis and Clark Bicentennial Commission call St. Charles home: the Discovery Expedition of St. Charles and the Lewis and Clark Fife and Drum Corps.

Pioneer Daniel Morgan Boone also made St. Charles history. It was he who paved the way through the St. Charles countryside for the Boone's Lick Trail, which later joined and became the Santa Fe Trail and then the Oregon Trail.

St. Charles can boast many firsts. The site of Missouri's first state capitol was here from 1821 to 1826. St. Rose Philippine Duchesne's shrine and the first Society of the Sacred Heart school in America that she helped establish are here. The first interstate highway in the United States, Interstate 70, had its beginnings in St. Charles.

However, the town has not survived without tragedy and an occasional natural disaster, including a cholera epidemic in 1832 and 1833, a devastating tornado in 1876, and disastrous

railroad bridge accidents in 1879 and 1881. The city's resilience in the face of these challenges is a testament to its citizens' fortitude and determination.

In fact, the citizens of St. Charles know how to celebrate their colorful past and have fun doing it. Each year, St. Charles hosts many events for the enjoyment of residents and visitors, including Christmas Traditions, when costumed carolers and legends of Christmas stroll Main Street and interact with holiday revelers; Riverfest, the town's Independence Day celebration; and Festival of the Little Hills, which focuses on the theme of Lewis and Clark and the early explorers. St. Charles is proud of its diversity and celebrates the heritage of many of its inhabitants with Tartan Days, a Scottish celebration held each spring; Oktoberfest to celebrate its German settlers; and Irish Heritage Days, held each September. Fleur de Lis is held each spring in Frenchtown, and Fete de Glace (Festival of Ice) takes place on Main Street in January.

It is no wonder thousands of visitors flock to St. Charles each year. Saturday evenings in downtown St. Charles are alive with music and celebrations all year long and with outdoor dining and concerts during the warmer months. Yet a Sunday stroll down Main Street in the historic district or a lazy picnic by the Missouri River is a trip back in time. Despite the flow of traffic in and out of St. Charles, the steady growth of industry and entertainment venues, and the booming development of towns further west, St. Charles, in some ways, remains the same town that hosted early adventurers and held steady against those disasters of long ago. The ancient buildings that have bordered the cobblestones of Main Street for generations still stand. The residents of St. Charles work hard to maintain ties to the city's rich history, embracing the future while refusing to abandon its past—even as the population of the county that bears its name continues to grow at an ever-increasing pace. During the early days of the St. Charles historic district's restoration, Virginia Musterman Tschudin was one of South Main Street's first shop owners and antique dealers. The following is an excerpt from Tschudin's "Greetings from Old South Main," published in 1980 in *Poems Through the Years*: "The first old street near river's edge / With ancient houses, side by each / Whose windowed eyes, over / [rocky] ledge / Into tomorrow, peer and reach . . . / In your mind's eye, you still may see / A weathered trapper trudging in / Laden with pelts to get his fee / According to what his catch has been.... / So very fortunate are we / Remains this same old street / The houses here for all to see / A historic picture will complete."

In this 200th anniversary year of the incorporation of the village of St. Charles, it is fitting to take a look back at the beginnings of this little river town, the lives of its many people, and even the challenges and hardships they have overcome with dignity and grace. Happy birthday, Les Petites Côtes.

One

IN THE BEGINNING

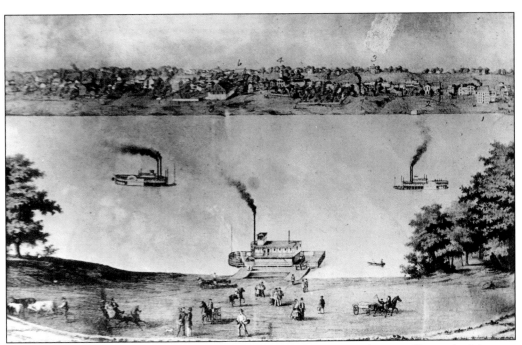

In 1856, the town of St. Charles was rapidly growing, as was steamboat traffic on the Missouri River. This sketch shows St. Charles, as seen from the other side of the river in St. Louis County. The artist is unknown.

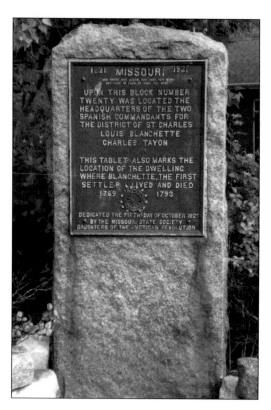

"Upon this block number twenty was located the headquarters of the two Spanish commandants for the district of St. Charles: Louis Blanchette, Charles Tayon," this marker reads. The tablet also marks "the location of the dwelling where Blanchette, the first settler, lived and died, 1769–1793." Dedicated in 1921 by the Missouri State Society Daughters of the American Revolution, the marker stands on South Main Street.

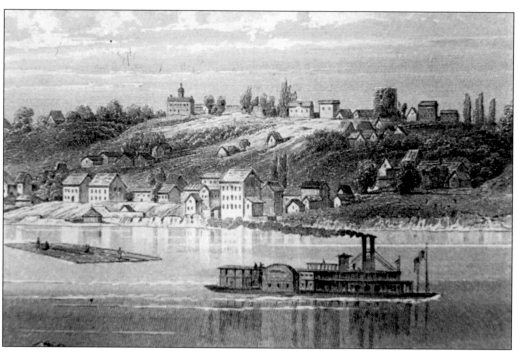

Another sketch of the St. Charles river scene in 1856 is depicted here, indicating the gently rolling hills that may have given Les Petites Côtes its name.

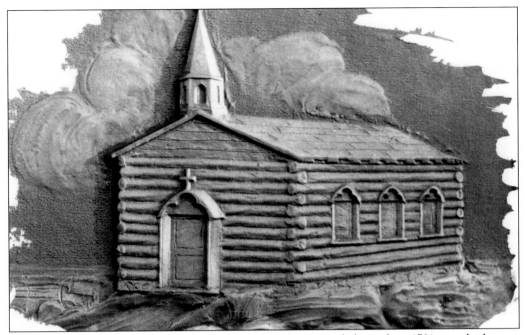

This artwork depicts the first church of Les Petites Côtes, dedicated in 1791, at which time the settlement was under Spanish rule. The church was named for San Carlos Borromeo (St. Charles Borromeo). Its Creole Mississippi–style architecture, *poteaux en terre*, referred to its upright timbers. The log church was replaced by a stone one in 1828.

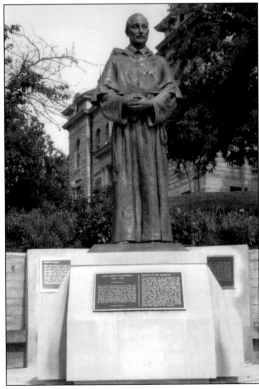

A statue of St. Charles Borromeo stands on the grounds of the courthouse. The saint was born in 1538 and died in 1584. It is for him that the first church of Les Petites Côtes was named, and the village eventually adopted the saint's name as well.

13

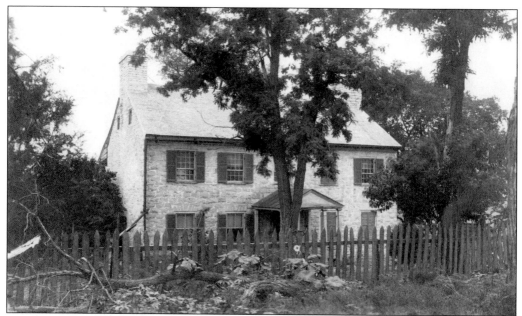

The home of Nathan Boone, Daniel Boone's son, is located in St. Charles County, a short distance from the city of St. Charles. Nathan built the house on property that he traded for a horse and bridle. Daniel occasionally resided in his son's home, and it was here that he died in 1820. It is believed that Daniel carved the walnut mantelpieces on the fireplaces. This photograph was taken during the 1920s, but the house has since been opened to visitors as a museum.

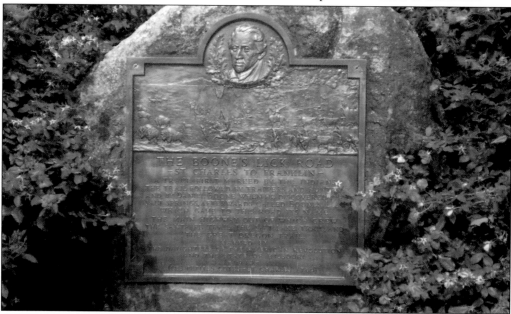

A monument to early explorers and to Boone's Lick Road was erected in front of the county courthouse by the Daughters of the American Revolution in 1913. The marker reads, "A trace first marked by the Indians; The trail followed by trappers and hunters and by Daniel Boone when he discovered Salt Springs, afterward called Boone's Lick . . . out of which grew the Santa Fe Trail, the Salt Lick Trail, and the great Oregon Trail."

14

Doc Carr, shown here in about 1856, was known as one of the more colorful early characters of St. Charles. Legend states that he was inventor of the corncob pipe, which he supposedly whittled and sold for a nickel each. Carr also dabbled in various careers as a hunter, Native American fighter, baggage man, and newspaper editor.

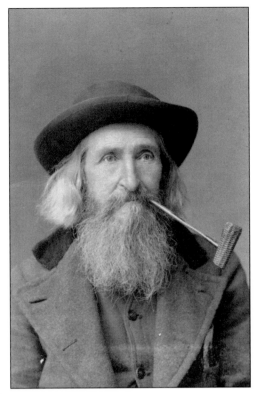

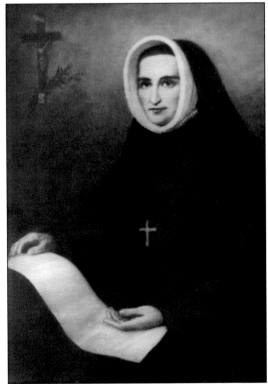

Mother Rose Philippine Duchesne was born in France in 1769. In 1818, she and four other nuns came to St. Charles, and in a little log cabin, they founded the first school of the Society of the Sacred Heart in America. At the age of 72, Duchesne fulfilled a lifelong desire to serve as a missionary to Native Americans and began work with the Potawatomi Indians in Sugar Creek, Kansas. She later returned to the school in St. Charles she had founded. She died at the convent in 1852 and is enshrined in a chapel on what is today the campus of the Academy of the Sacred Heart. She was declared a saint in the Catholic Church in 1988 by Pope John Paul II. (Courtesy of the Academy of the Sacred Heart.)

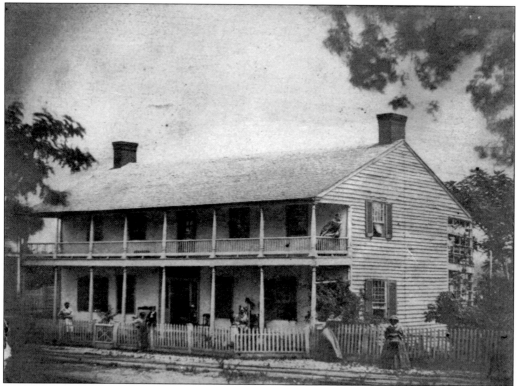

The home of Dr. Henry Behrens in about 1850 was located at Clark and Main Streets. Behrens cared for Mother Rose Philippine Duchesne during her last illness before she died in 1852.

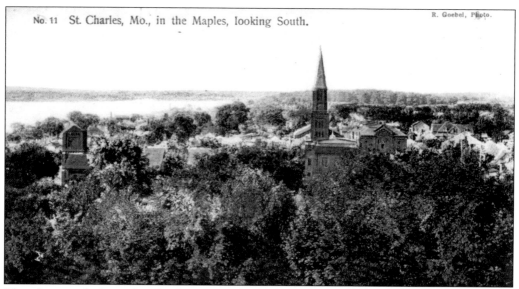

No. 11 St. Charles, Mo., in the Maples, looking South.

R. Goebel, Photo.

This photograph shows St. Charles in 1858, looking south.

Two

MANY FIRSTS

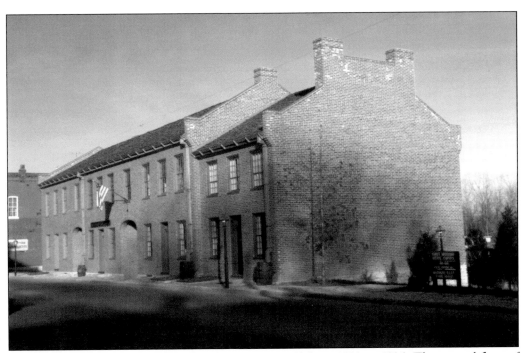

St. Charles was the site of Missouri's first state capitol from 1821 to 1826. The second floor of two adjoining brick buildings, which still stand today, was divided and used as senate and house chambers, the governor's office, and a committee room. The first floor of one of the buildings housed a general store owned by the Peck brothers, Charles and Ruluff. Chauncy Shepard operated a carpenter shop on the first floor of the adjoining building. This photograph was taken around 1965 after the buildings, located at 200–216 South Main Street, underwent construction to restore the rooms to their original state.

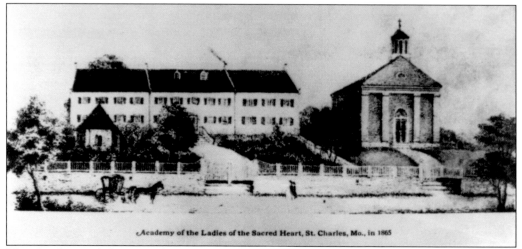

Academy of the Ladies of the Sacred Heart, St. Charles, Mo., in 1865

The Academy of the Sacred Heart, established in 1818 by Rose Philippine Duchesne, was the first Society of the Sacred Heart School in America. This picture shows the academy in about 1865. Once a school for young women, it now opens its doors to both boys and girls for pre-kindergarten through eighth grade.

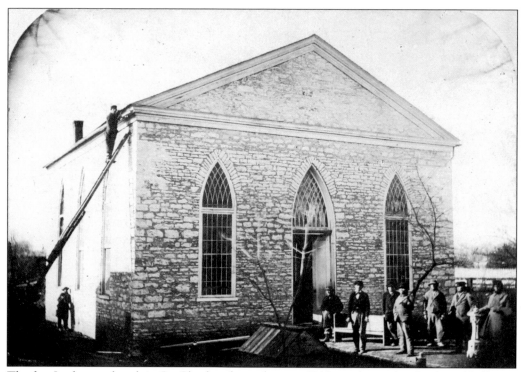

The first Lutheran church in St. Charles, shown here in 1866, was located at Sixth and Jefferson Streets. It was built in 1849, and the last service in the building was held on February 3, 1867. A new church building was constructed to house a growing congregation.

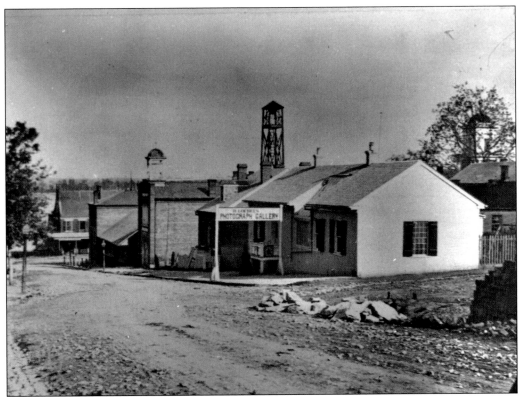

The first public school in St. Charles opened in 1867 and was located at 131 Jefferson Street. Rudolph Goebel later used the building as a photography studio. The building is shown here in 1960.

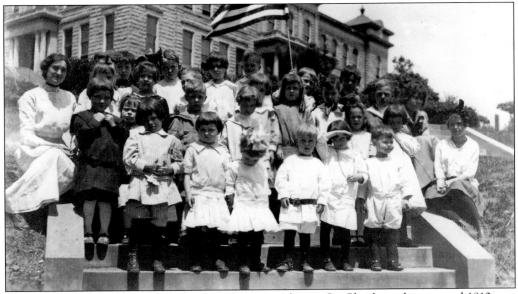

Pictured here is the first public school kindergarten class in St. Charles, taken around 1910.

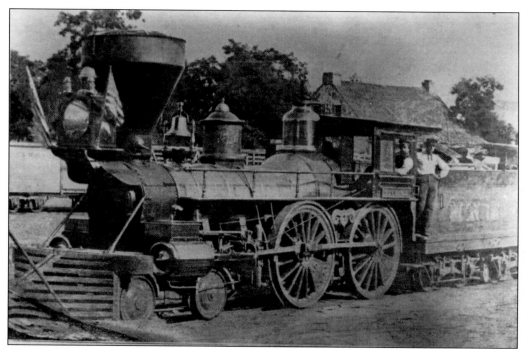

The first locomotive in St. Charles chugs along the North Missouri Railroad in about 1856. The engineer can be seen in the window in this photograph taken by Rudolph Goebel, and another man stands by the coal car.

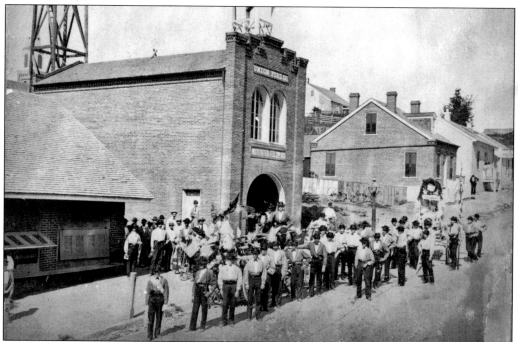

The first fire hall in St. Charles was dedicated on February 2, 1861, and was located on Jefferson Street between Main and Second Streets. The Union Fire Company is shown marching in front of the fire hall.

The first Methodist church stood at 617 South Main Street in this photograph taken by Ryne Stiegemeier on December 26, 1966. A historic marker on the front of the building today states that it is the oldest existing brick church north of the Missouri River. Catherine Collier built the church for her Methodist congregation, and it was used until the early 1850s, when a larger structure became necessary.

In 1884, the Franciscan Sisters of St. Mary were asked to send nurses from their hospital in St. Louis to St. Charles to care for victims of the scarlet fever/diphtheria epidemic. In 1885, the sisters were offered the building at 305 Chauncey Street to use as a hospital. This became the first St. Joseph's Hospital and had only 20 beds. Today the building is a private residence.

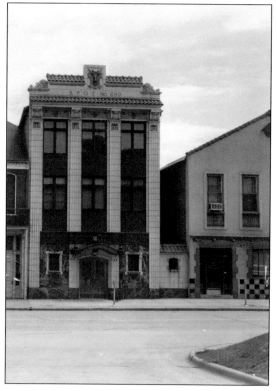

The first Masonic hall, located at 122 South Main Street, is shown here in 1950 when it was the Benevolent and Protective Order of Elks (BPOE). The BPOE sign still exists on the front of the building, which is today the home of a computer software firm.

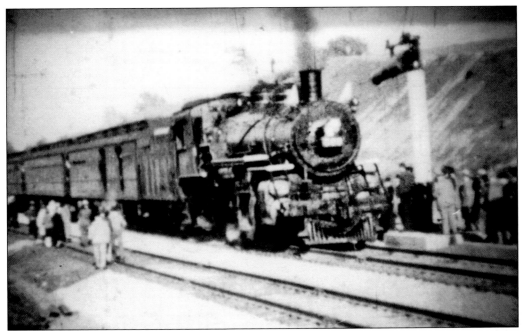

The first train to cross the new Wabash Bridge in 1937 carried Pres. Franklin D. Roosevelt in one of its cars. It was built to replace an older bridge that had undergone reconstruction after disastrous accidents in 1879 and 1881. The new bridge was meant to handle heavier locomotives that traveled at faster speeds. It cost $3 million to complete.

The first governor of Missouri, Alexander McNair, lived in this home at 703 Second Street during the time that St. Charles was the first capital. The photograph was taken between 1880 and 1890. The building no longer stands.

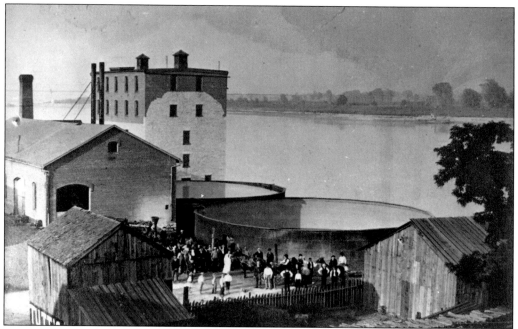

In 1880, the first St. Charles Water Works stood at the foot of Monroe Street. In 1901, new land was purchased at 12 South Main Street for the municipal waterworks powerhouse and settling basins, which began operating in 1903.

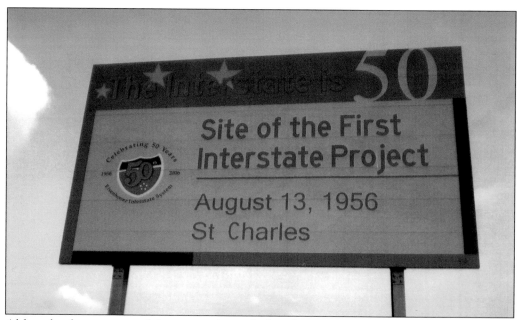

Although three states claim ownership of the first interstate (Missouri, Kansas, and Pennsylvania), on August 2, 1956, Missouri was awarded a contract for work on what is now Interstate 70/Mark Twain Expressway in St. Charles. On August 13, this became the first interstate project to be awarded and to start construction after Pres. Dwight D. Eisenhower signed the Federal-Aid Highway Act of 1956.

Three

LIFE ON THE RIVER

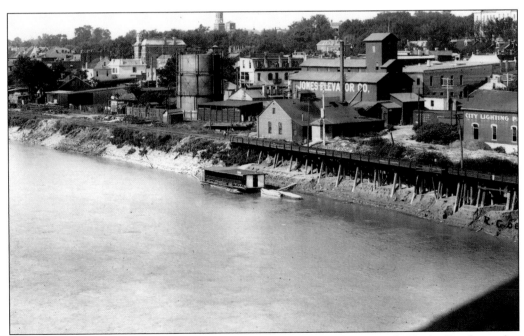

Taken from an area near Jones Elevator Company, City Lighting, and Wright Brothers, this photograph affords a panoramic view of the St. Charles waterfront in 1907.

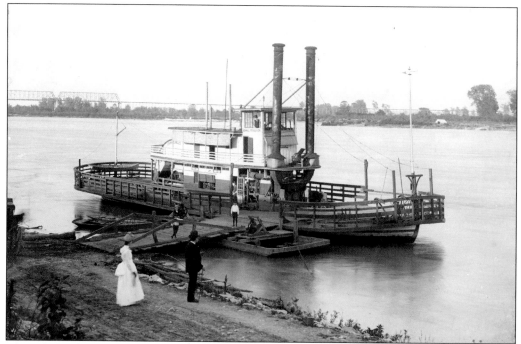

The John L. Ferguson ferry operated in the St. Charles area in the late 1800s. The boat was launched from Grafton, Illinois, in 1876 and was destroyed in 1886; it was about 112 feet long and 26 feet wide.

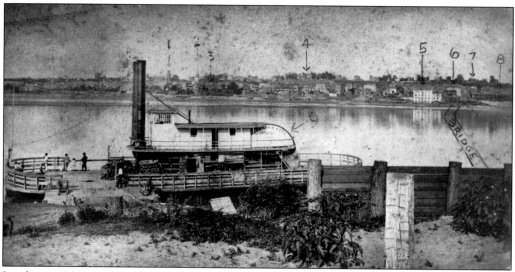

In about 1868 or 1869, St. Charles was growing rapidly. In this scene on the St. Charles waterfront, various structures have been numbered: St. Peters Church (1), under construction; the Baptist church (2); the old courthouse (3); St. Charles College (4); the roller mill (5); Galt Hotel (6); Brokelman House on Third Street (7); St. Charles Car Works (8); and the *Nebraska City* ferryboat (9).

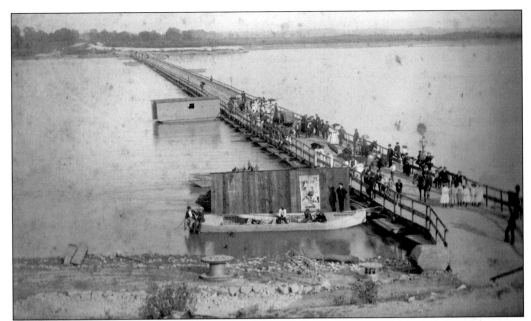

The pontoon bridge was designed by Capt. John Enoch. It measured about 1,500 feet long and connected St. Charles with Bridgeton in St. Louis County. Construction was completed in 1890, and the bridge opened in June with tolls of 5¢ per horseman and 40¢ per buggy. However, the bridge lasted only until November of that same year, when ice flows and rising water broke it apart.

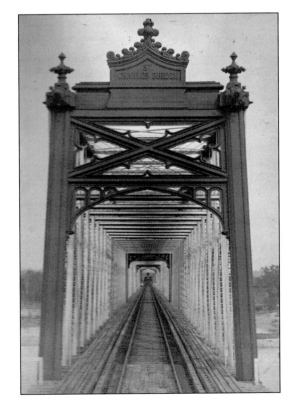

A train approaches St. Charles in 1871, as shown here from the entrance to the old Wabash Bridge. The first Wabash Bridge opened on May 29, 1871, and at 6,335 feet, it was one of the longest in the United States at that time. The stone piers extended into the river from 54 to 75 feet below the water line.

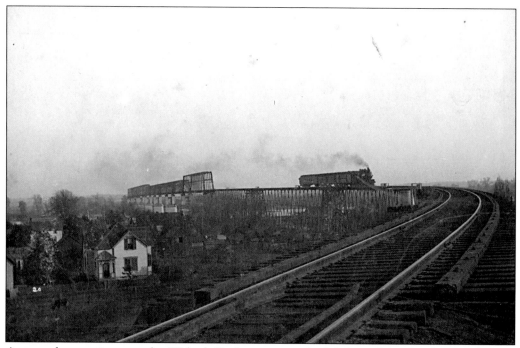

A steam locomotive uses the Wabash Bridge to cross the Missouri River in about 1899 as it approaches the St. Charles depot. In 1881, a span of the 1871 bridge collapsed, and this reconstructed bridge was used until 1936.

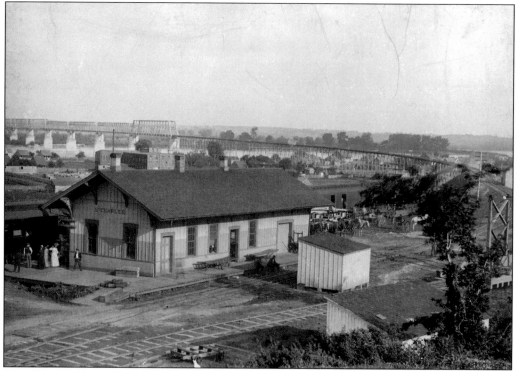

The old Wabash Bridge and railroad depot are shown here in 1900.

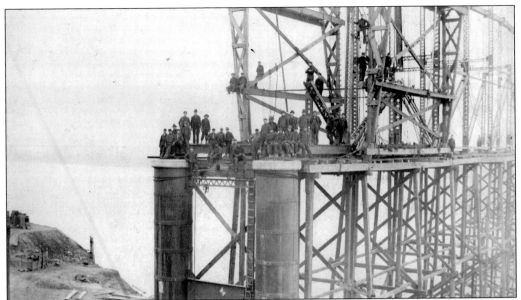

In 1902, construction began on the Highway 115 bridge. The bridge cost $400,000 to build, and four men lost their lives during its construction. The bridge opened in 1904 in time for the Louisiana Purchase Exhibition in St. Louis, with trolley car rides costing 5¢ apiece. At that time, the Highway 115 bridge was the only automobile bridge connecting St. Louis County and St. Charles. Fire damaged the floor of the bridge in 1916, and repairs cost between $150,000 and $200,000. In 1992, the bridge was permanently closed due to structural problems. It was demolished in 1997.

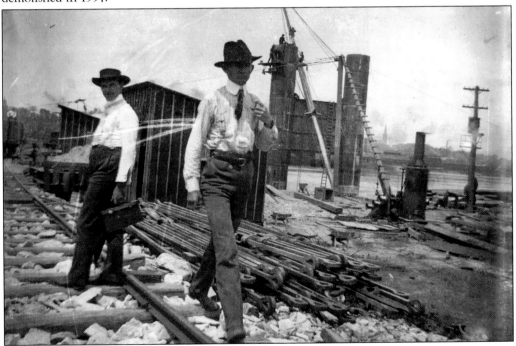

Construction of pillars for the Highway 115 bridge was being completed in 1903 in preparation for its 1904 opening.

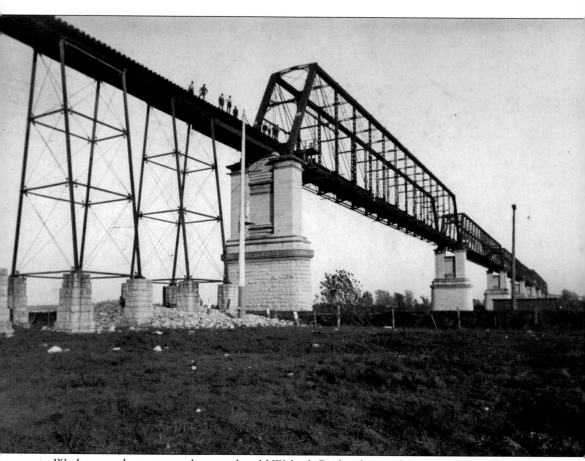

Workers can be seen standing on the old Wabash Bridge during the early 1900s. The bridge was reconstructed after the 1881 collapse, and the original sections of hanging spans were replaced by overhead spans.

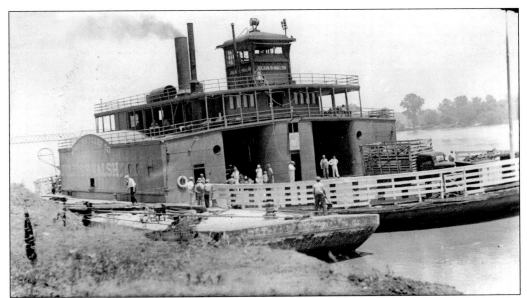

The *Julius S. Walsh*, shown here in St. Charles in the 1920s, was a large ferryboat with a capacity of 64 automobiles. It is reported to have sunk at the St. Louis levee in the spring of 1936.

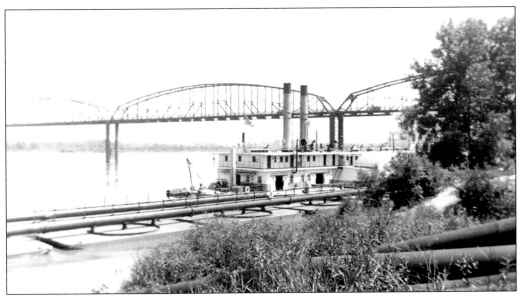

The Highway 115 bridge forms the backdrop for this steamer, shown here on the Missouri River around 1920. Steamboats began to travel the Missouri River during the 1800s.

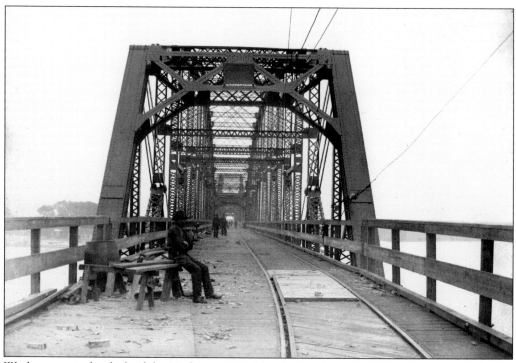

Workers repair the deck of the Highway 115 bridge during the early 1920s. Streetcar tracks can be seen on the right side of the bridge floor.

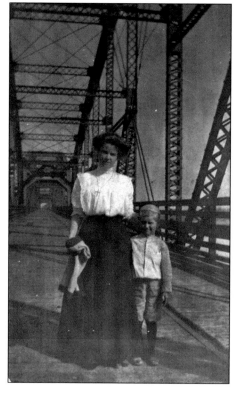

In about 1910, Lillie Holtschneider and her son, Bo, posed for a photograph on the Highway 115 bridge.

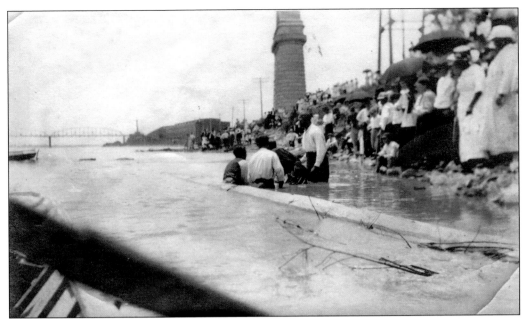

A baptism ceremony was held in the flooded Missouri River in about 1920, and members of the congregation gathered to participate.

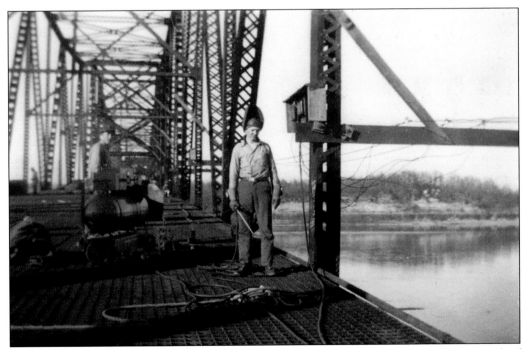

In 1936, a new Wabash Bridge was built, costing $3 million. It was erected one-half mile north of the old bridge and was required to handle the heavier locomotives that traveled at higher speeds. Shown standing on the bridge are a construction worker and a welder with his equipment.

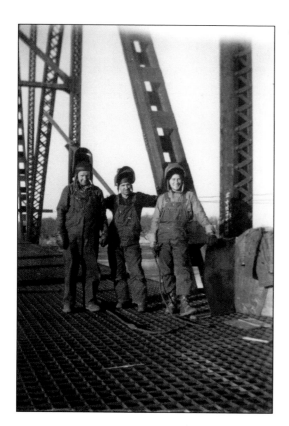

Three welders work on the new Wabash Bridge construction in 1936.

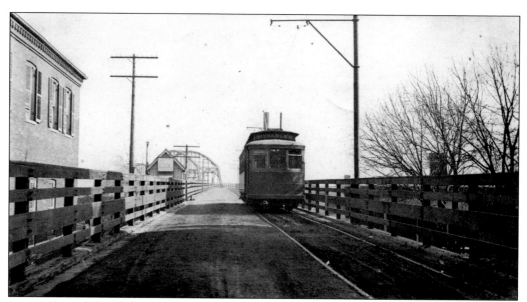

Streetcars used the Highway 115 bridge to travel between St. Charles and Wellston in St. Louis County. The streetcars ran from 1904 until January 18, 1932. The bridge continued to be used for automobile and bus traffic until 1992.

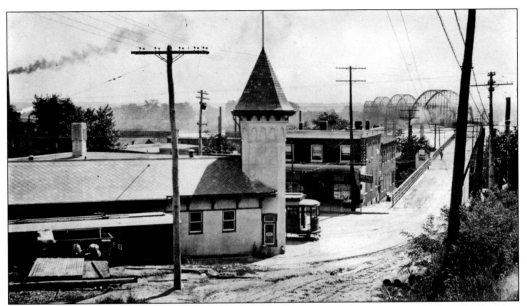

The Highway 115 bridge could easily be seen from the terminal bus station, which today holds a small business office. The bridge was destroyed in 1997.

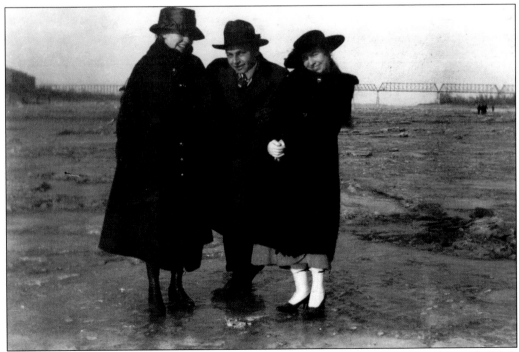

Oliver Heck takes a stroll on the frozen Missouri River during the 1920s or 1930s with Edith Rauch (left) and Bernice "Bunny" Rauch. Edith and Bunny were sisters; Edith later married and took the name Emmons. (Courtesy of JoAnn Trogdon.)

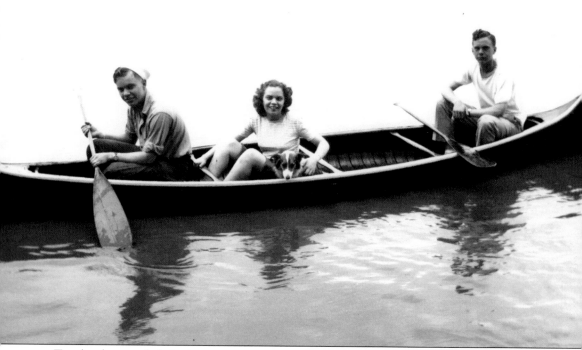

Two brothers and their sister enjoy a canoe ride on the river around 1950. From left to right are Jack Heck, Lucy Heck, and Henry Heck. Lucy later married and took the name Graveman. (Courtesy of JoAnn Trogdon.)

Four

CHURCHES AND SCHOOLS

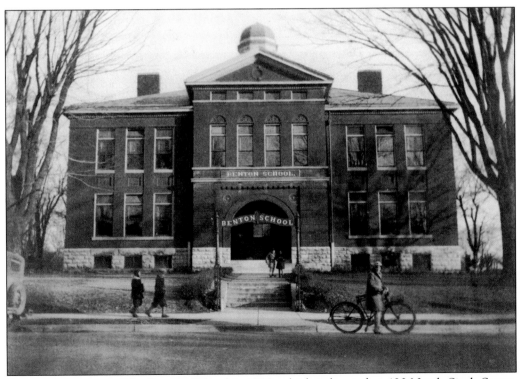

Boys in knickers stroll by Benton School in 1920, which is located at 400 North Sixth Street. The school was founded in 1896 and was, during its operation, the oldest school in the St. Charles City School District. The school board voted in 2006 to close the school. In 2008, the building began undergoing renovations to become administrative offices for the district.

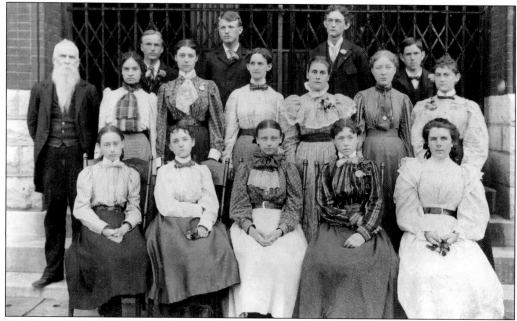

The Benton School graduating class in 1895 included, from left to right, (first row) Betty McDearmon, Laurie Wright, Ada Miller, Edmonia Edwards, and Vernie Loonam; (second row) Professor Jones, Bertha Dunlap, Eva Lemmon, Pearl Nolfolk, Mollie Loonam, Helen Boedecker, and Birdie Vaughn; (third row) Fred Allmeyer, Will Fitzgerald, Charles Hafer, and Julius Mallenchrodt.

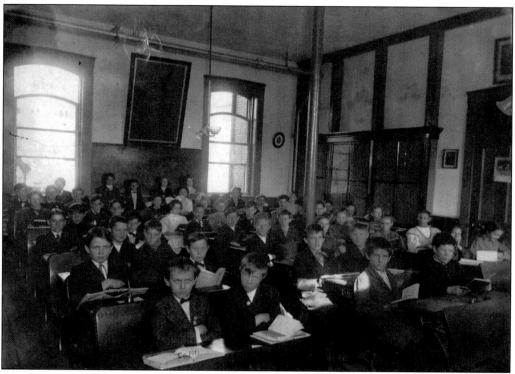

Children sit in their desks at St. Charles Borromeo School in 1907.

After St. Charles Borromeo Church was destroyed by a windstorm in 1915, rebuilding began the following year. The new church was nearly complete in this photograph from 1917.

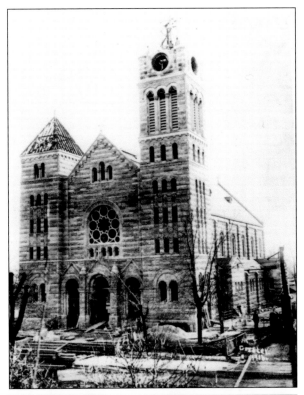

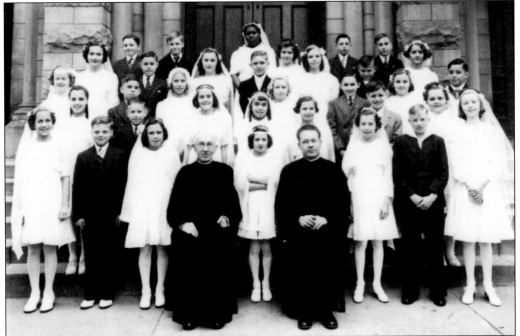

Sixth-grade students at St. Charles Borromeo School celebrate their first communion in 1940. The mother of author Don Graveman, Lucy Heck, appears in the fourth row, fifth from the left.

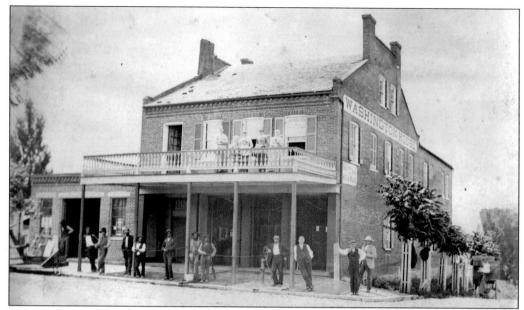

The Washington House is located on the southeast corner of First Capitol Drive and Sixth Street. The house was built in 1860 and was used as a military school during the Civil War. After the school closed, the building became the Washington House Hotel, owned by Herman D. Bruns. Later it was the home of Earl F. Klippel. Today the main floor is home to the Corner Bar and Grill. The Cocked Hat Bowling Alley is located in the basement.

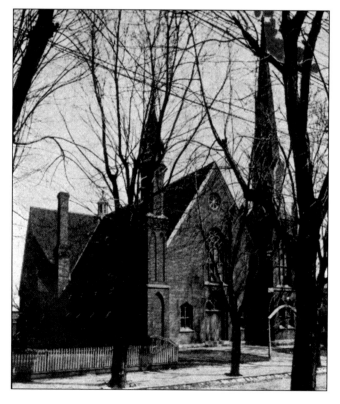

First Presbyterian Church, pictured here in the 1900s, was demolished in the 1960s in order to make room for a new post office at Fifth and Madison Streets.

The German Methodist School was located at Third and Clay Streets. Shown here is a class photograph from the 1900s.

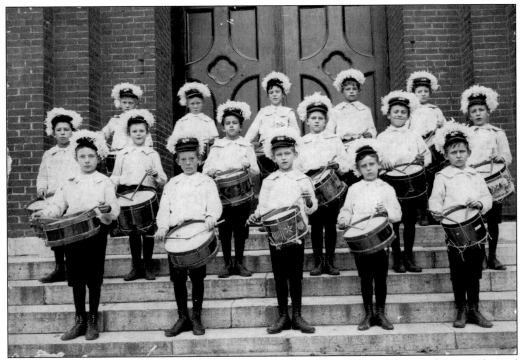
In 1900, the boys' snare drum band from St. Peters Catholic Church featured these uniformed young men with feathered hats.

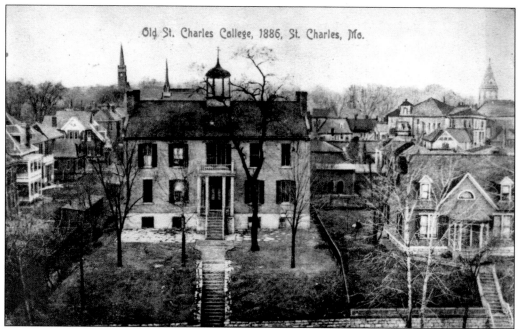

St. Charles College was the first boys' school in the Mississippi Valley or west of the Mississippi River. During the Civil War, Lt. Col. Arnold Krekel took the school building to be used as a hospital. The basement became a prison with military guards. Pictured here in 1886, the building is located at Third and Jefferson Streets.

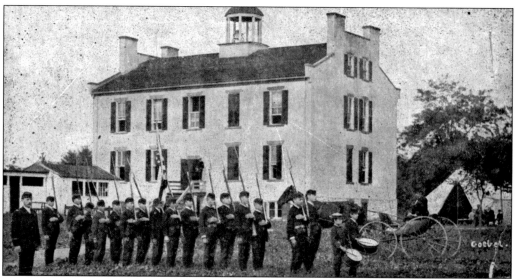

Students of the old St. Charles College march in formation in front of the school in 1860. The school was founded in 1835.

The St. Charles Business College was in operation during the 1920s.

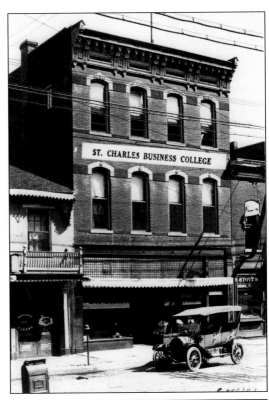

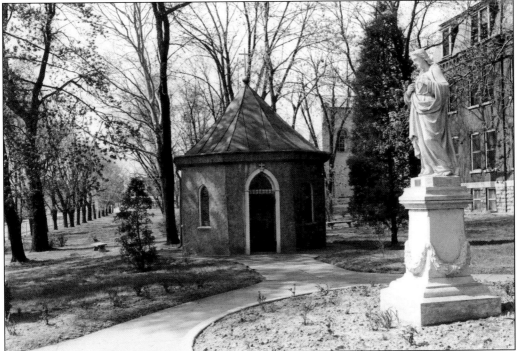

The roundhouse at the Academy of the Sacred Heart was the first shrine of St. Rose Philippine Duchesne, founder of the school in 1818.

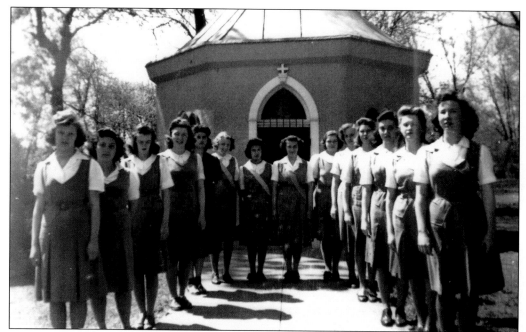

Academy of the Sacred Heart students stand near the roundhouse on the school campus in the 1940s where St. Rose Philippine Duchesne was buried for nearly 100 years. Her remains are now interred in the chapel that was built on school grounds after her beatification. (Courtesy of Academy of the Sacred Heart.)

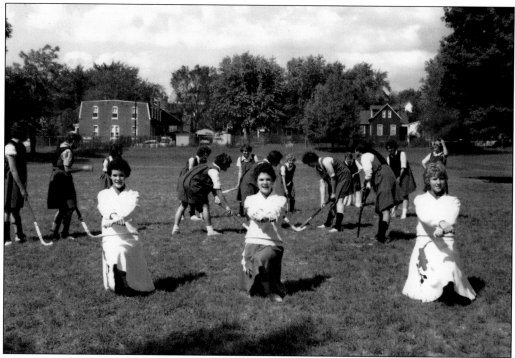

Cheerleaders root for the field hockey team playing on the Academy of the Sacred Heart's campus in the 1960s. (Courtesy of Academy of the Sacred Heart.)

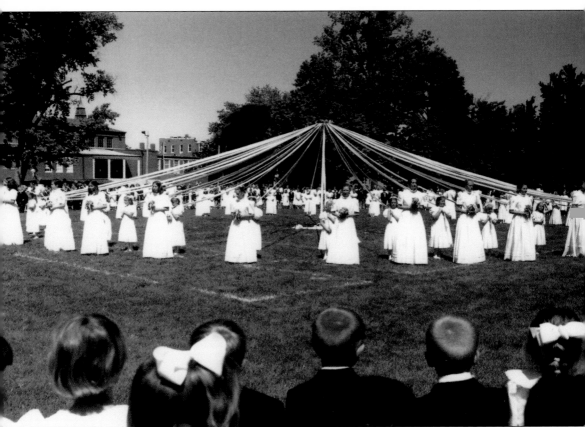

The maypole is a time-honored tradition at the Academy of the Sacred Heart and has been performed by students since at least the 1940s. After the high school closed in 1972, there were no longer senior girls to perform the beloved exercise. The eighth graders assumed the honor, joined by second-grade girls wearing their white first communion dresses. (Courtesy of Academy of the Sacred Heart.)

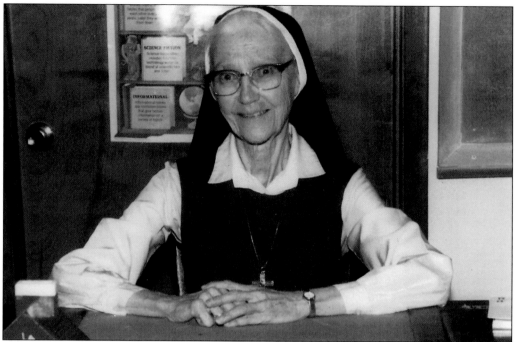

Sister Anna Mae Marheineke was born in St. Charles in 1917 and attended the Academy of the Sacred Heart as a child. She later returned to become one of the best-loved educators at the academy. Over the years, Marheineke was responsible for educating three generations of St. Charlesans, including future teachers, lawyers, an FBI agent, and a St. Charles County circuit court judge. (Courtesy of Academy of the Sacred Heart.)

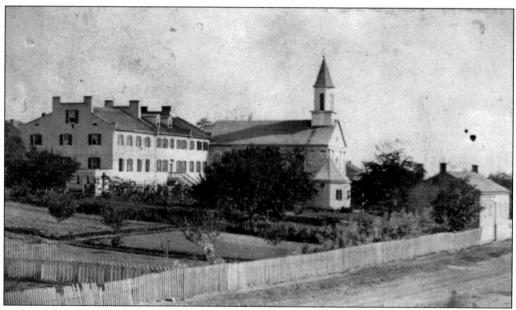

The Academy of the Sacred Heart was founded in 1818 and is still in operation today. The roundhouse and the old convent buildings can be seen in this picture from 1880.

St. John's United Church of Christ, as it appeared in the 1920s, shows scaffolding around the steeple. In 1925, a new roof was installed and a cross was placed at the top of the steeple. This photograph was most likely taken at that time.

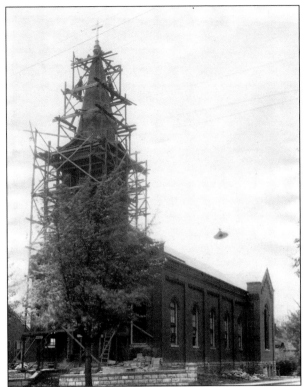

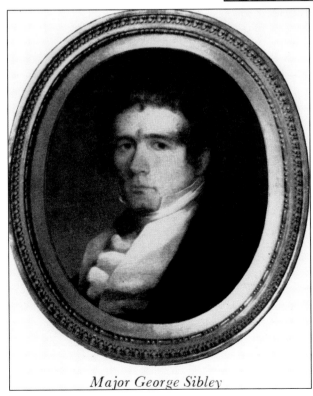

Major George Sibley

Maj. George Sibley was in charge of Fort Osage from 1808 to 1826. During a trip through the St. Charles countryside, he took an interest in the area and bought some land. He named his property Linden Wood for the abundant groves of linden trees. It was at this site that he and his wife, Mary Easton Sibley, later established Lindenwood College for young women.

Lindenwood College originated in 1827 and was the first woman's college west of the Mississippi River. Today Lindenwood University is a four-year liberal arts school located on a 500-acre campus, with an enrollment of approximately 14,000 students. The J. Scheidegger Center for the Arts, which opened in 2008, attracts big-name acts such as Liza Minelli and Hal Holbrook to the area.

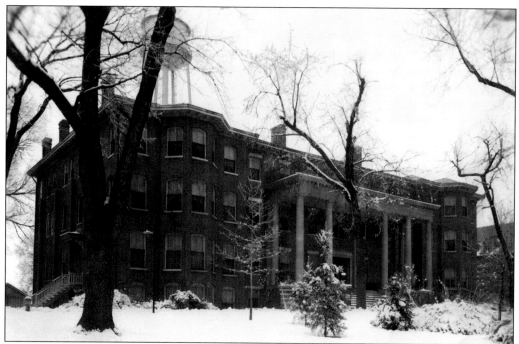

Dedicated in 1860, Sibley Hall was named after the college's founders, George and Mary Sibley. Listed on the National Register of Historic Places as the oldest building on campus, today Sibley Hall is a dormitory for female students.

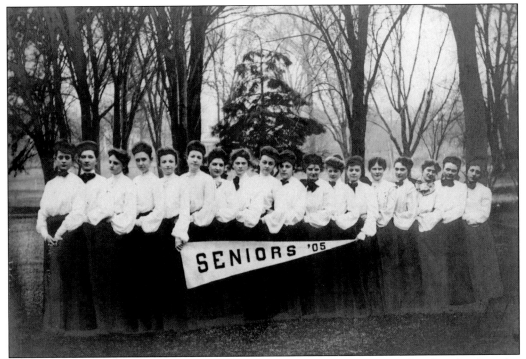

The Lindenwood College senior class poses in 1905. Originally an all-girls school, today Lindenwood is a coeducational university.

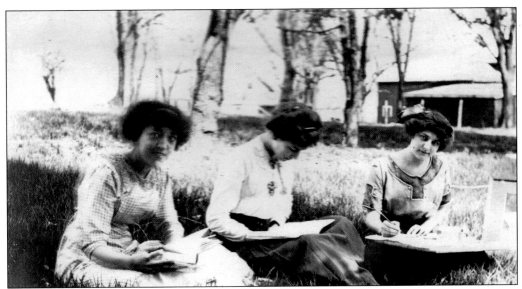

Lindenwood students enjoy study time on the campus lawn in the 1900s.

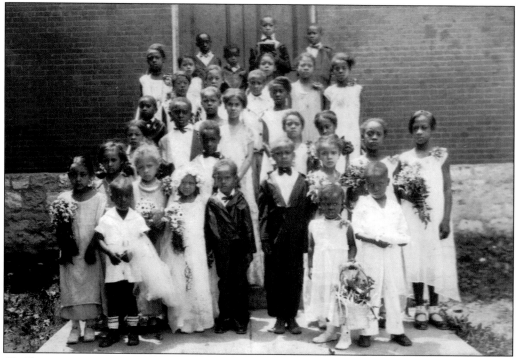

Children participate in a mock wedding at St. John's AME (African Methodist Episcopal) Church in about 1928. The congregation of St. John's AME church began in 1855.

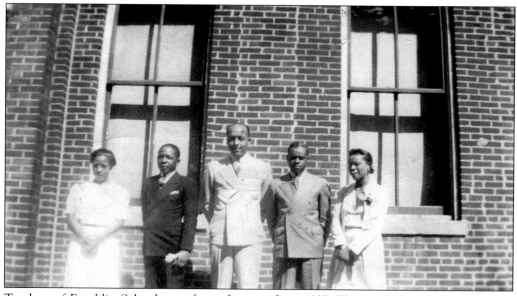

Teachers of Franklin School pose for a photograph in 1937. They include, from left to right, Miss Sittles, Mr. Clinton, Mr. Kelly, Mr. Washington, and Mrs. Moore. The property was sold to the City of St. Charles by the parish of St. Charles Borromeo in 1870 and became the second school for African American children in St. Charles. The first was Lincoln School. The St. Charles City School District was later desegregated.

Five

DEFENDING TOWN AND COUNTRY

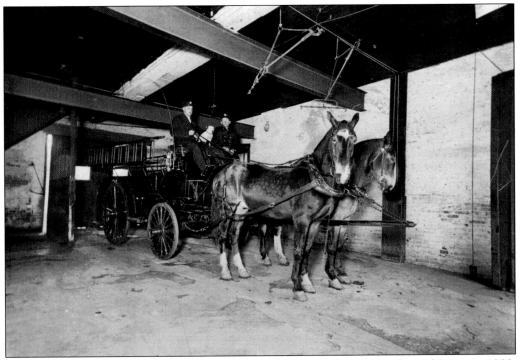

The St. Charles Volunteer Fire Department, Hose No. 2, was located on Second Street in 1900. Horse-drawn wagons raced to the scene when there was a fire.

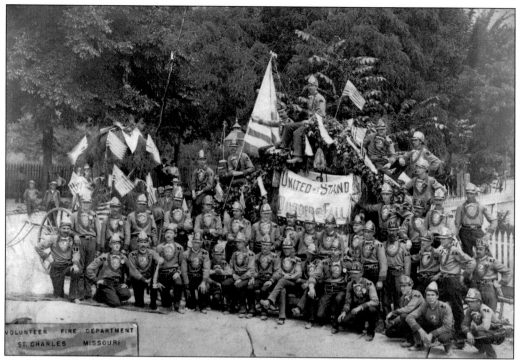

Members of the St. Charles Volunteer Fire Department pose for a photograph in 1892. Their banner reads, "United We Stand, Divided We Fall."

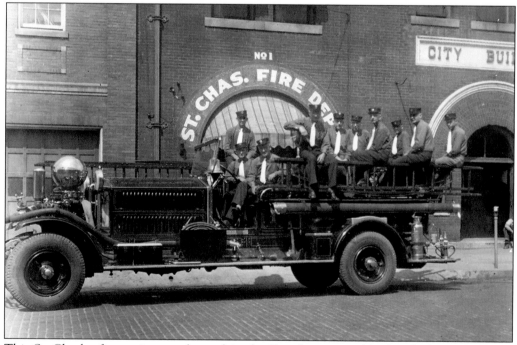

This St. Charles fire station was located in the Frenchtown neighborhood of St. Charles in 1920. Members of the department pose in dress uniform. Charlie Cope is seated above the back wheel.

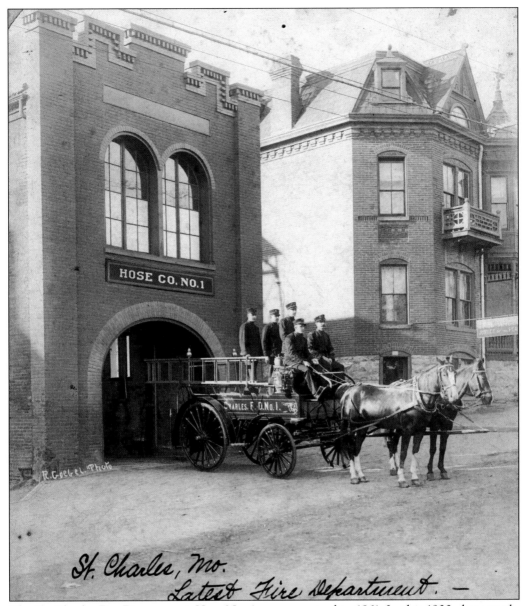

HOSE CO. NO.1

CHARLES. F. D. No. 1.

R. Goebel. Photo

St. Charles, Mo.
Latest Fire Department. —

The St. Charles Fire Department, Hose No. 1, was organized in 1861. In this 1900 photograph, Fire Chief Lewis Ebeling is seated to the far right. The firehouse was located on Jefferson Street between Main and Second Streets. A sign can be seen on the brick home next door that reads, "Fred Knoop, Justice of the Peace." The team of horses was purchased from the St. Louis Fire Department.

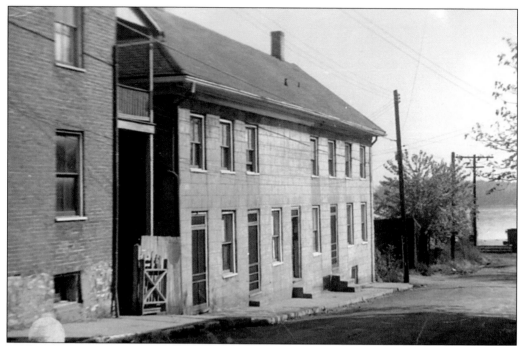

A stone fort, as it appeared in 1950, was reportedly constructed for protection during the French and Indian War that ended in 1763. It was later used as a fur trading post. The building was torn down in about 1960.

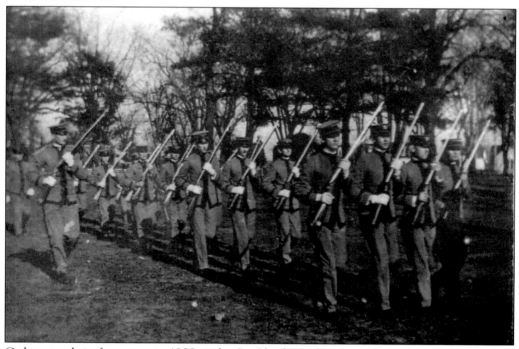

Cadets march in formation in 1908 at the St. Charles Military Academy. After a fire partially destroyed St. Charles High School in 1918, a new high school was built on this location at the corner of Kingshighway and Waverly Streets.

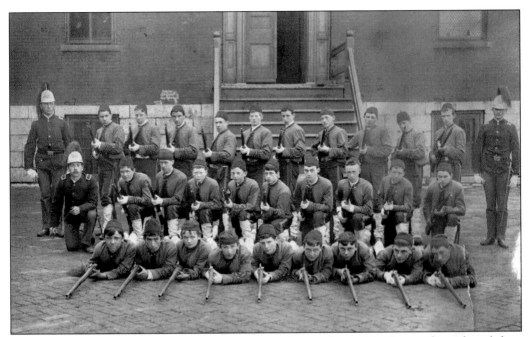

A St. Charles Military Academy class poses with rifles in about 1880. Pictured are, from left to right, (first row) ? Murphy, J. McGee, E. McAndres, J. Aylward, P. Leustgain, ? Wilson, J. Cosgrove, J. Lahey, and A. McHugh; (second row) ? Murray, Joe Kane, Jim Corrigan, J. Pickford, T. O'Keefe, C. Mulligan, ? Tracy, L. Braunschweig, and J. Gibbons. The third row is unidentified.

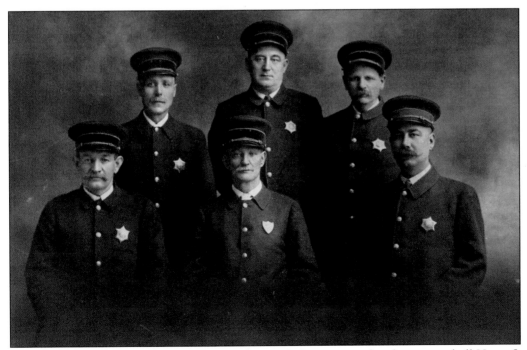

Members of the St. Charles Police Department in 1913 are pictured with city marshall Henry J. Linnebur (center, first row).

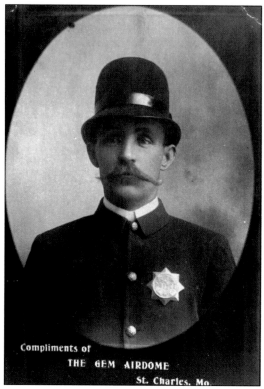

Officers David Lamb (left) and John Blair (below) were killed in the line of duty on December 6, 1913. The officers were shot while trying to arrest three gamblers who had earlier been told to leave town but refused. In an exchange of gunfire, one of the suspects was shot and killed by Lamb. The other two suspects were captured about 10 miles east of the city of St. Charles. The trial for Harry and Andrew Black began on May 11, 1914, in circuit court and led to a double execution. Lamb was 46 years old when he was killed, and Blair was 45. Two additional St. Charles city police officers have died in the line of duty: Fred Bergmann in 1976 and Gary Stroud in 1977. Three members of the St. Charles County sheriff's department have fallen in the line of duty: John Dierker in 1916, Albert Musterman in 1969, and Richard Henke in 1971.

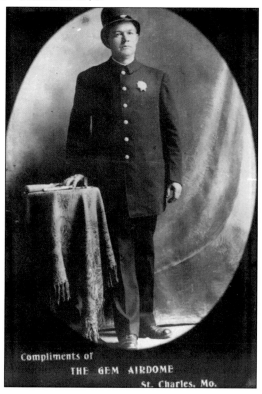

John Blan was executed by hanging on June 6, 1879, in St. Charles. This incident was reported to be the first lawful hanging in St. Charles, and it took place in the jail yard at Second and Madison Streets. Blan was found guilty of shooting his employer, Elijah Warren, after the two had an argument. The execution was carried out by Sheriff Joseph Ruenzi.

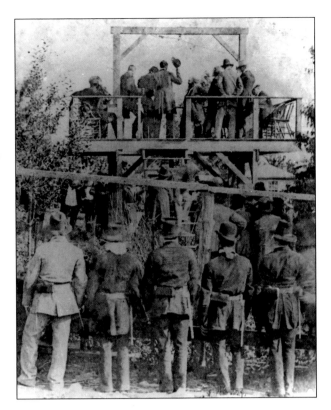

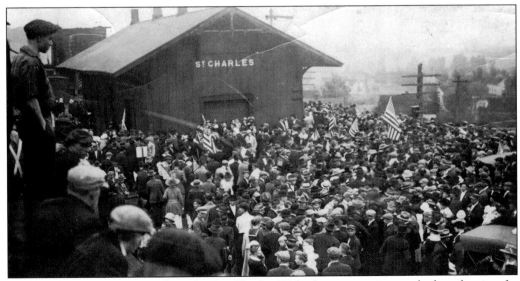

Crowds of people bid farewell at the St. Charles Wabash train station to draftees leaving for service in World War I. This photograph was taken about 1917.

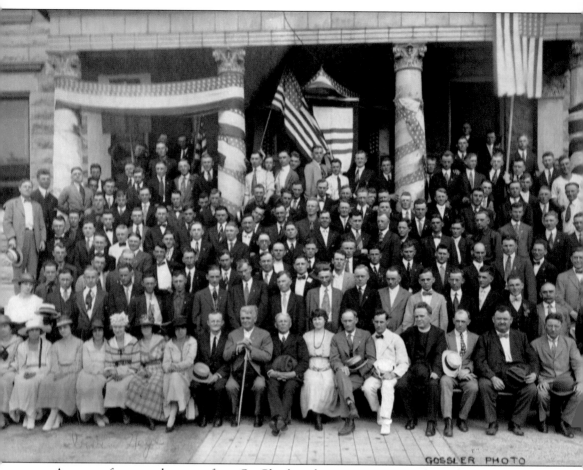

A group of men and women from St. Charles who are preparing to leave for service in World War I pose in front of the county courthouse. The photograph was taken by J. Gossler.

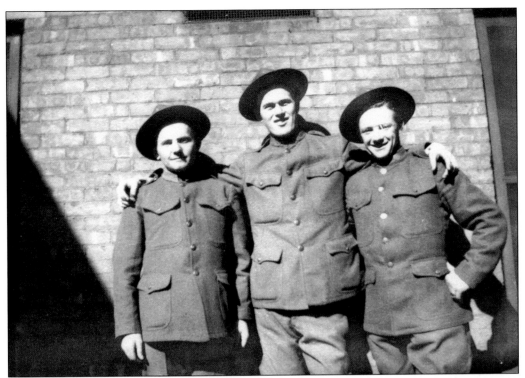

Three soldiers from St. Charles share a smile for the camera in 1918.

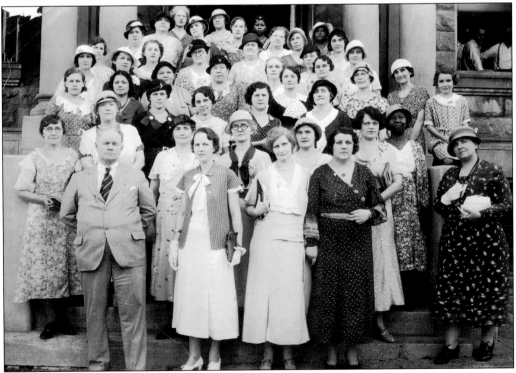

Workers with the St. Charles chapter of the Red Cross are pictured here in 1930.

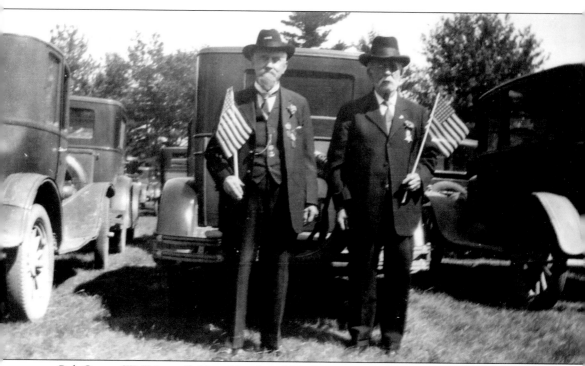

Col. George W. Tainter (left) and his friend Mr. Burton attend the Grand Army of the Republic (GAR) reunion in the early 1920s. Burton had lost his sight. The GAR was founded in Decatur, Illinois, in 1866 by Benjamin F. Stephenson. Membership was reserved for honorably discharged veterans of the Union Army, Navy, Marine Corps, and the Revenue Cutter Service who had served between April 12, 1861, and April 9, 1865.

Six

Business as Usual

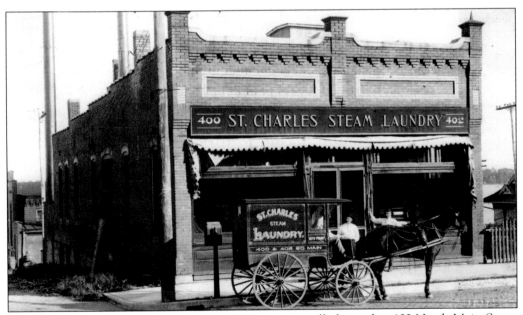

St. Charles Steam Laundry, founded in 1895, was originally located at 122 North Main Street before relocating to this newer building at 400–402 South Main Street in the early 1900s. The horse-drawn company wagon stands ready for deliveries.

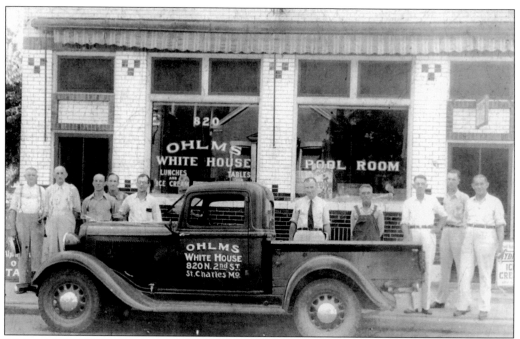

Ohlms White House, a diner and pool room, was located at 820 North Second Street. Edward A. Ohlms, the proprietor, stands third from left. Today this building houses an antique furniture and lighting company.

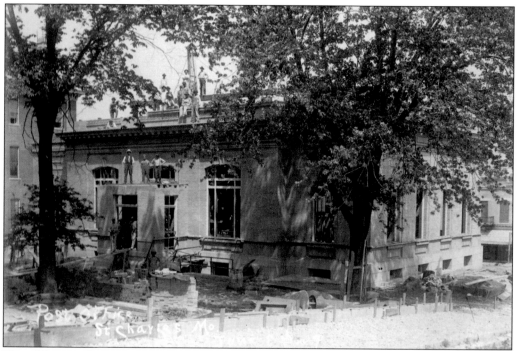

The old post office, constructed in 1909 at a cost of $60,000, was located at 312 North Main Street. In this photograph, the building is not yet complete. The current post office moved to Fifth Street during the 1960s.

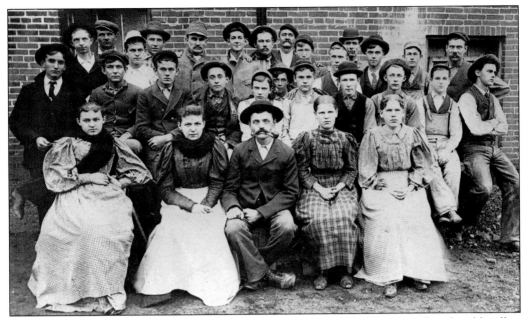

The St. Charles Corn Cob Pipe Company was organized in 1895 and operated in the old mill at Boone's Lick Road and South Main Street. Doc Car, an early pioneer in St. Charles, is believed to have invented the corncob pipe. The town of Washington later opened three factories and prospered in the corncob pipe business, and the St. Charles corncob pipe faded into history. Shown here are Corn Cob Pipe Company employees in 1896.

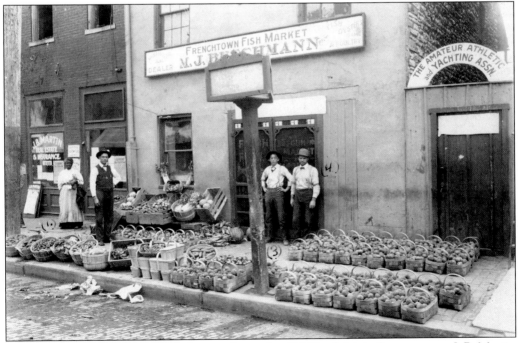

In 1908, the Frenchtown Fish Market was located at 316 North Main Street next to J. B. Martin Real Estate and Insurance. The Amateur Athletic and Yachting Association was also next door. Pictured from left to right are Mrs. Stewart, Tom Colbrier, Ole Wehmeyer, and Doc Bushman.

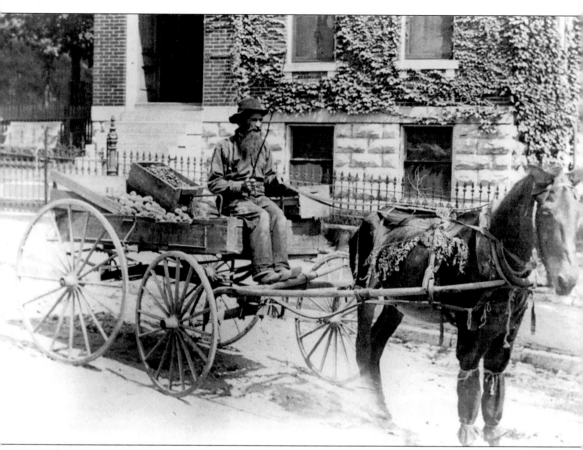

Simon Moser, born about 1837, was nicknamed "Old Mr. Mose" by those who knew him. His horse's name was Whoa, Mike. Moser died in May 1914. He is pictured here in about 1910.

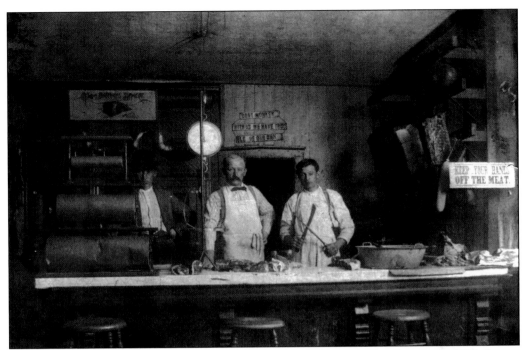

The interior of the Kemper Meat Market, located at Fifth and Clay Streets in 1900, boasts colorfully worded warnings such as, "Don't Monkey With Us; We have Trouble of Our Own," seen behind the butchers, and "Keep Your Hands Off the Meat," seen to the far right.

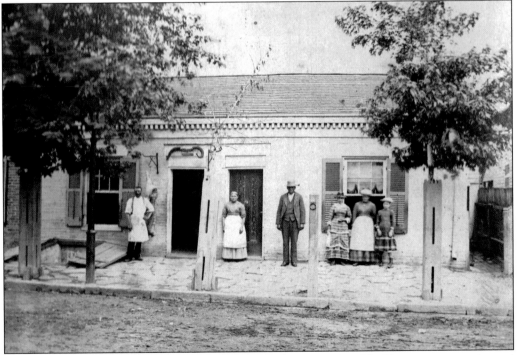

Huebling Butcher Shop stood at 909 North Second Street. Mary Huebling, center, is pictured here in the late 1800s.

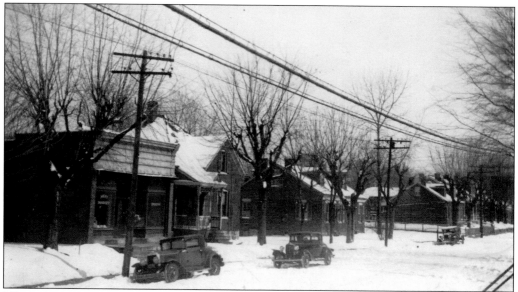

Iffrig's Store, as it appeared in the 1920s, is the first building on the left. It was located at 816 Adams Street.

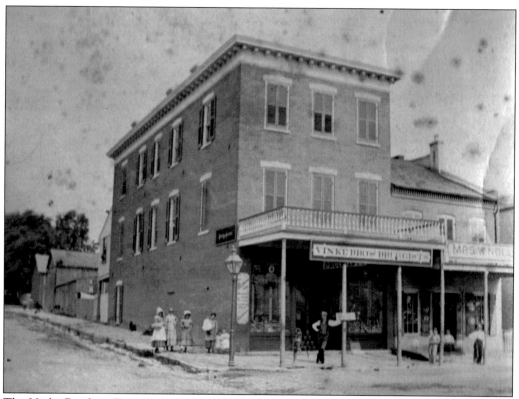

The Vinke Brothers Druggists were at 901 North Second and Morgan Streets. Pictured here in about 1906, the building included two floors of living quarters above the drugstore. A hat shop was next door at 903 North Second Street.

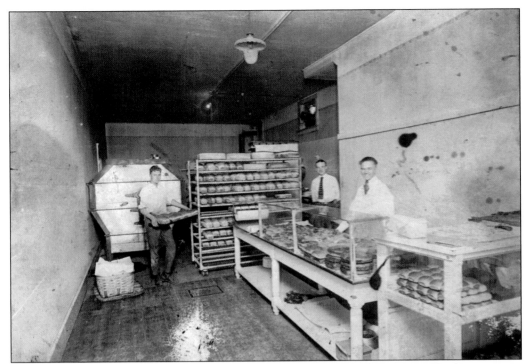

Bakers prepare their breads and sweets for customers at an early bakery in St. Charles.

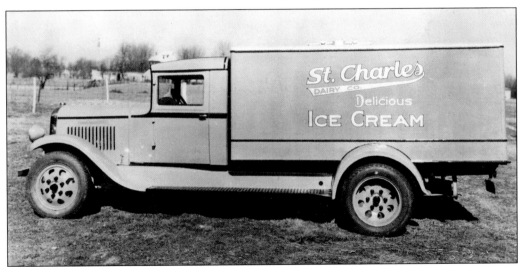

A St. Charles Dairy truck advertises the company's tasty ice cream in March 1931. St. Charles Dairy, established in 1918, was located on First Capitol Drive. The company was sold in 1983.

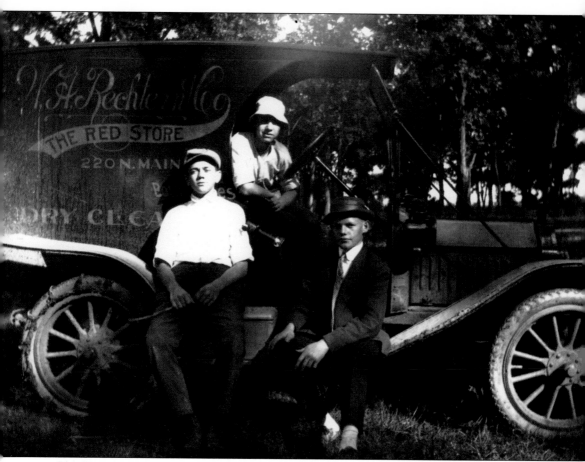

Three young men take a break alongside the Red Store company truck in the 1920s. The Red Store, owned by W. Rechtern, was located at 220 North Main Street. The building later housed American Clothing Company in the 1970s and today is home to another retail business. However, the "Red Store" lettering is still visible on the floor of the entrance to the building on Main Street. (Courtesy of Jo Ann Trogdon.)

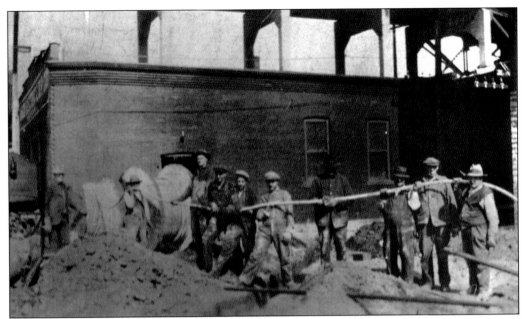

Workmen install electrical feeders out of the Adams Street substation. Elmer Aye is at left.

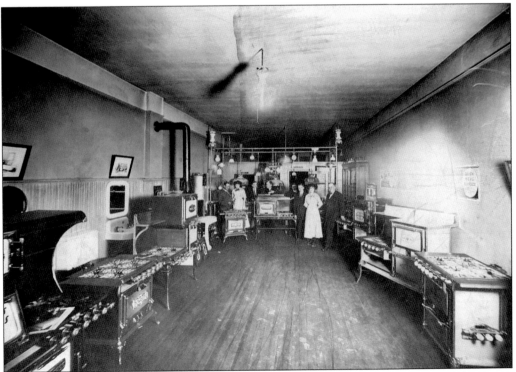

In 1910, St. Charles Gas Company sales staff members proudly display gas stoves of the day in the showroom.

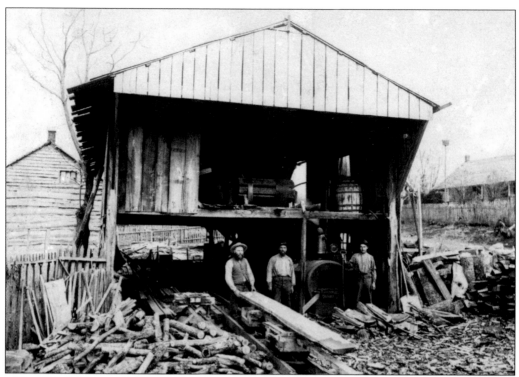

Three men labor in a St. Charles sawmill during the 1920s.

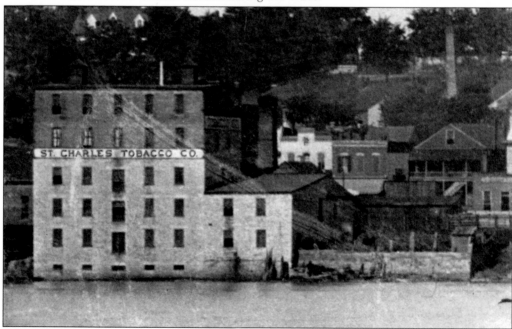

The St. Charles Tobacco Company, owned by the Wright Brothers Tobacco Company in 1890, was located at the foot of Adams Street on the riverfront. The building was originally Collier Mill in 1843; it was later sold and became a steam flour mill. The flour mill was the largest industry in St. Charles until it was closed in 1884 and sold to the tobacco company.

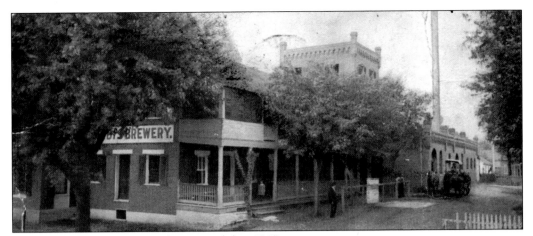

The Schibi Brewery appears here as it did in 1907.

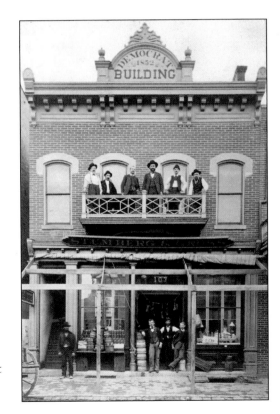

The Stumberg and Gross Store occupied the Democrat Building at 213 North Main Street in 1900. In 2008, the building is home to a group of small business consultants.

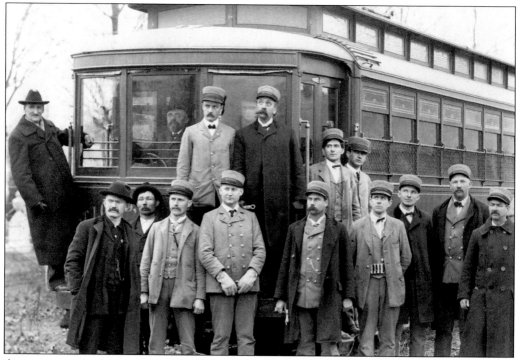

A motorman sits in a streetcar as other employees pose in front of the car in the early 1900s. Streetcars traveled the Highway 115 bridge from St. Charles to St. Louis until 1932.

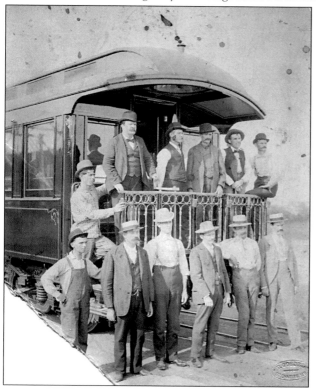

St. Charles Car Company men stand at the back of a railcar in the early 1900s.

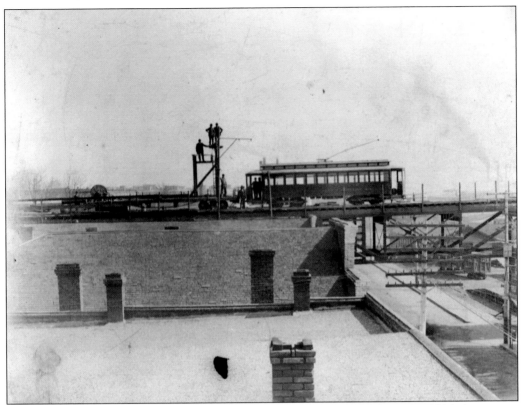

Construction of the Highway 115 bridge over the Missouri River is underway in 1904. A streetcar sits on the bridge approach.

In the early 1900s, the terminal bus station was located near the entrance to the Highway 115 bridge. The building today is occupied by a small business.

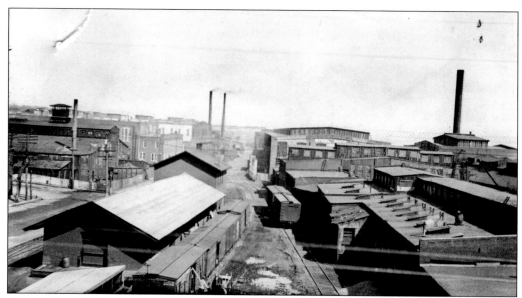

The Wabash Railroad terminal is pictured in the foreground. The ACF (American Car and Foundry) riverside plant is on the right and stretches into the background. Formed in 1899, ACF Industries, as it is known today, is a manufacturer of railcars, parts, and steel products.

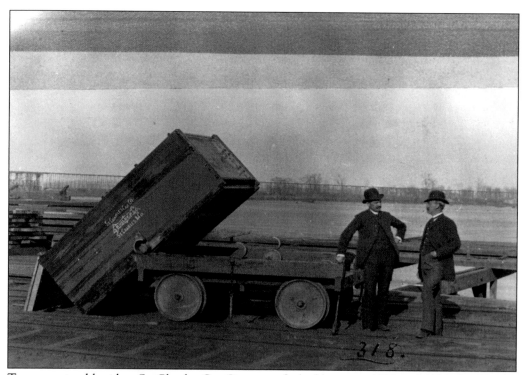

Two men stand beside a St. Charles Car Company flatbed between 1890 and 1900. St. Charles Car Company was founded around 1872; it later merged with 12 other companies in 1899 to form ACF.

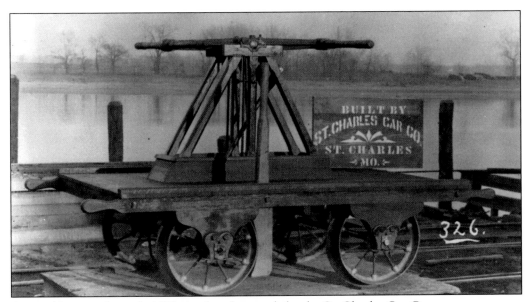

Pictured here in the early 1900s is a handcar made by the St. Charles Car Company.

Hotel St. Charles and the Highway 115 bridge could once be seen from the courthouse lawn. Neither the hotel nor the highway bridge still exist today.

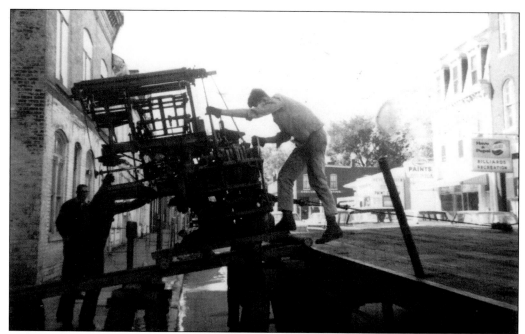

The St. Charles Banner News moved from Main Street to Fifth and Adams Streets in the mid-1960s. The St. Charles Banner News published under various names from 1903 until 1978 and was a principal newspaper for St. Charles County. Here newspaper employees move the press machine.

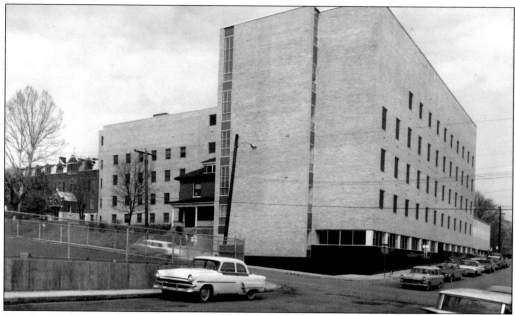

The first St. Joseph's Hospital in St. Charles was established in 1885 by the Franciscan Sisters of St. Mary, who came to St. Charles to help with a diphtheria/scarlet fever outbreak. In 1891, a larger building was constructed at the current location of the hospital on First Capitol Drive. Additional wings were added, and the facility became more modernized by the 1960s, as shown here. Today St. Joseph Health Center is a 352-bed acute care hospital.

Seven

LIFE AND TIMES
IN ST. CHARLES

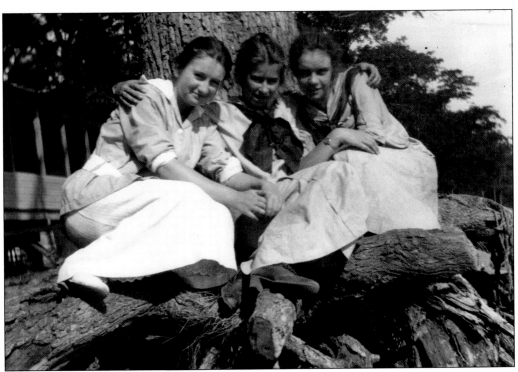

Sitting on the unearthed roots of a large tree, from left to right, are sisters Edith and Bernice "Bunny" Rauch and their cousin Lucille Rauch. Edith later married and took the name Emmons, and Lucille married and took the name Heck. The photograph was taken between 1915 and 1920. (Courtesy of JoAnn Trogdon.)

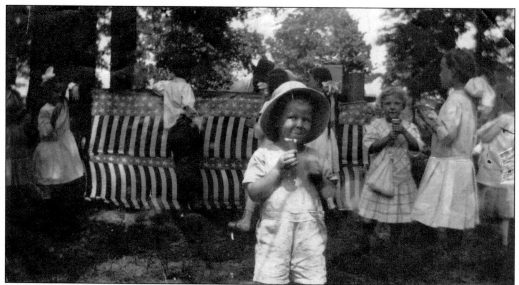

Bennie Woods's farm, located in 1920 near what is now the Heart of St. Charles Banquet Center on Fifth Street, provided an enjoyable afternoon of ice-cream tasting for area children.

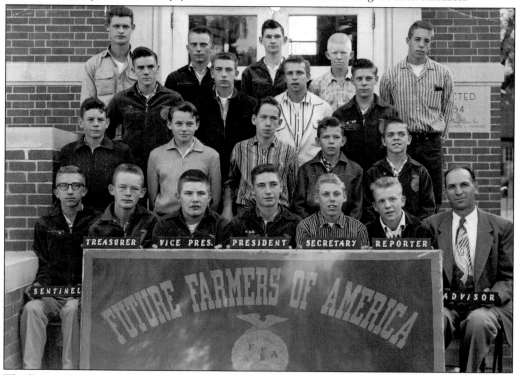

The Future Farmers of America, St. Charles chapter, pose in 1958 for a photograph. From left to right are (first row) Bernard Poeling, Roy Richterkessing, John Wortman, Julius Willott, Kurt ?, and Howard Zumbehl; (second row) Roy Zumbehl, Richard Toedebusch, Stanley Steinhoff, Paul Richterkessing, and Charles Schmidt; (third row) Seth Jones, Tom Dames, Robert Morrow, and Gerald Nothstine; (fourth row) Dewayne Bone, John Thies, Jack Houston, Ronnie Meers, and John Bruere. The group's advisor was Harold Landwehr.

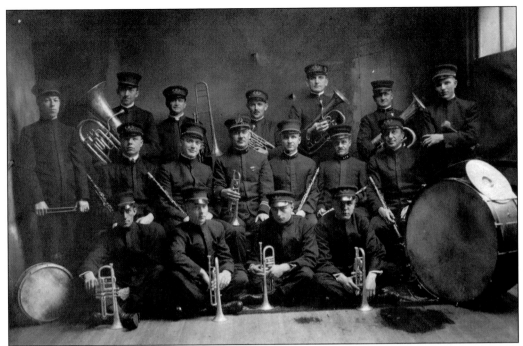

The St. Charles Municipal Band poses for a photograph taken between 1890 and 1900. Clarence Wessler sits on the floor by the drum. The municipal band still exists today and performs for special occasions in St. Charles.

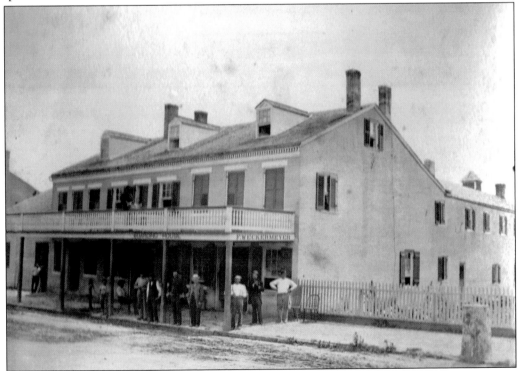

The F. Weckermeyer Boarding House stands at 409 South Main Street in 1906.

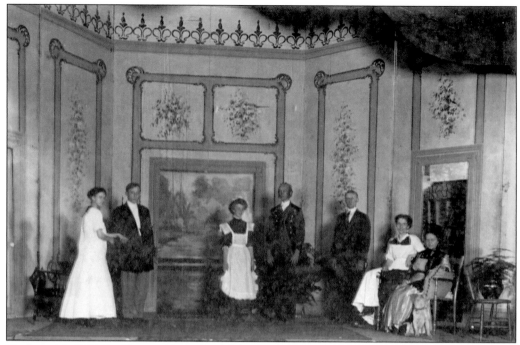

On June 16, 1910, St. Charles High School's senior class produced the play *Mr. Bob* at the opera house on North Main Street. The performers included, from left to right, Mildred Haussler, Roy Pallardy, Nora Schuesser, Eugene Hafer, Paul Goebel, Ella Raus, and Elsie Ueblerle.

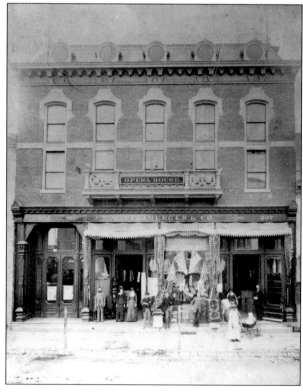

Pictured here in 1880, the Famous Opera House was located at 205–207 North Main Street. The building still stands today.

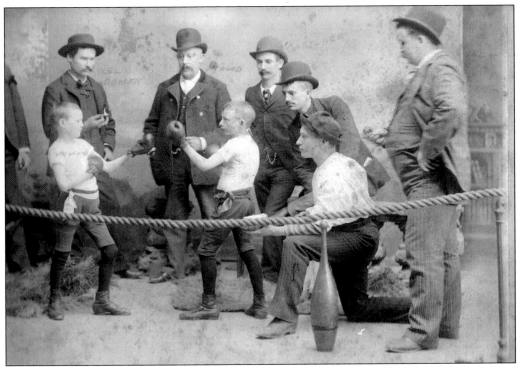

Young boxers in 1890 compete for the enjoyment of spectators.

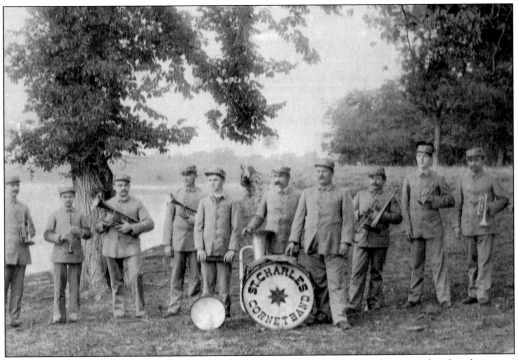

St. Charles Cornet Band members pose with their instruments in this photograph taken between 1880 and 1890.

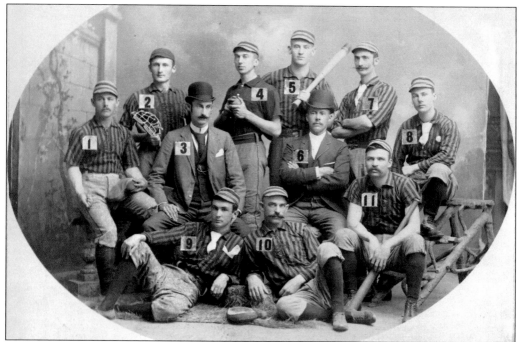

Members of the St. Charles baseball team in the 1890s include pitcher Joe Ehrhard (No. 4) and Joe Runge (No. 6). The other players are unidentified. The owner of the team is wearing a bowler hat.

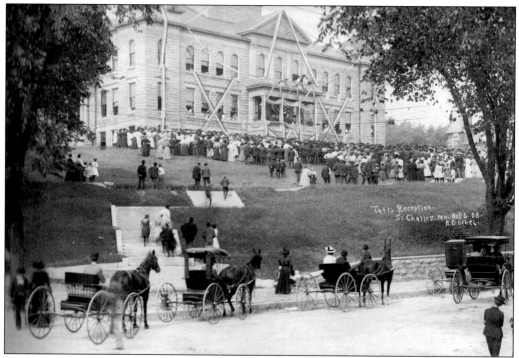

The St. Charles county courthouse is decked out in patriotic ribbons for Pres. William Howard Taft's reception on October 6, 1908.

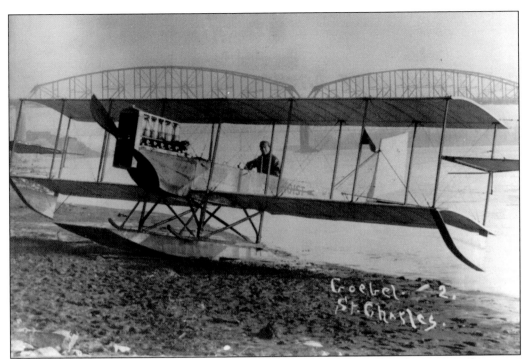

Daredevil stunt flyer Tony Janus lands his biplane beside the Missouri River. The Highway 115 bridge is seen in the background.

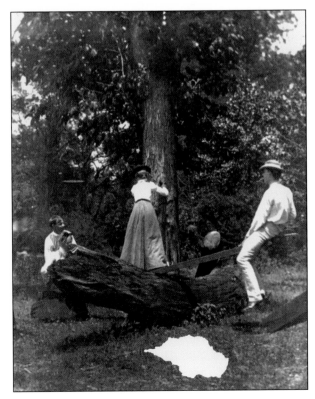

Some young adults, perhaps out for a picnic, form a makeshift seesaw out of logs and other materials about 1910.

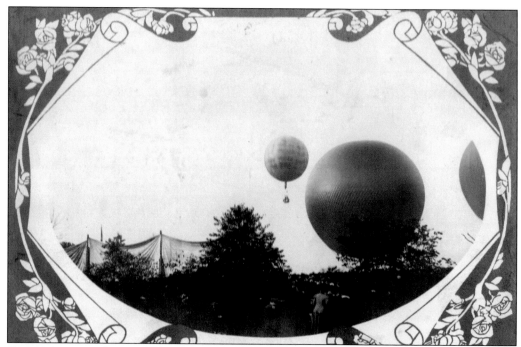

Spectators enjoy a hot-air balloon celebration in St. Charles, depicted on this postcard from 1878.

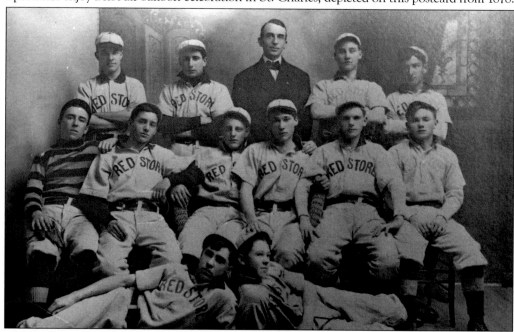

The St. Charles Red Store baseball team was sponsored by Rechtern's Store, also called the Red Store. Pictured from left to right are (first row) Doug Biard, second base; and Ralph Weber, left field; (second row) Herman Mades, catcher; Blaine Hedges, right field; Arthur Weber, pitcher; Joseph Saland, pitcher; Charles Schibi, right field; and Joseph White, third base; (third row) Anthony Bottani, shortstop; Edward Aymond, center field; Joseph Ehrhard, manager; John Werner, first base; and Oliver Denker, second base. The photograph was taken in 1910.

A baseball picnic celebration in 1915 was attended by, from left to right, Walter Bruns, Warner Briscoe, Joe Johnson, and Elmer Moehlenkamp.

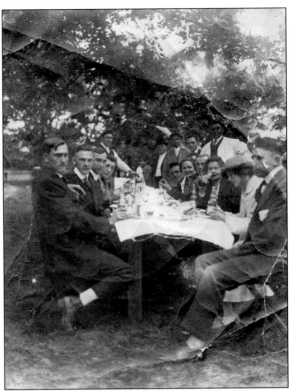

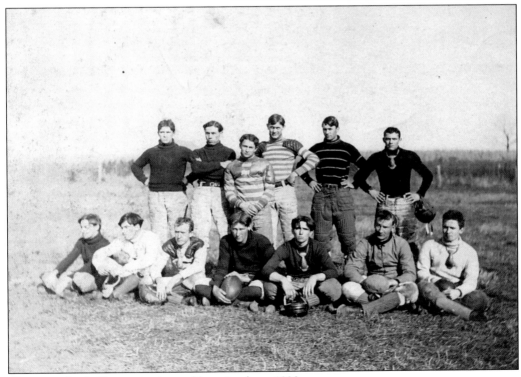

The town football team is pictured here in about 1920.

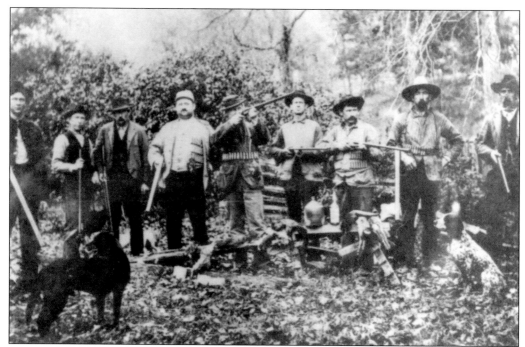

A hunting party in 1909 included, from left to right, Leo Struckhoff, Fritz Struckhoff, John Poepsel, Dr. Wentker, Dr. Tainter, Boss Bacon, Frank Schell, Fritz Poepsel, and Ben Poepsel.

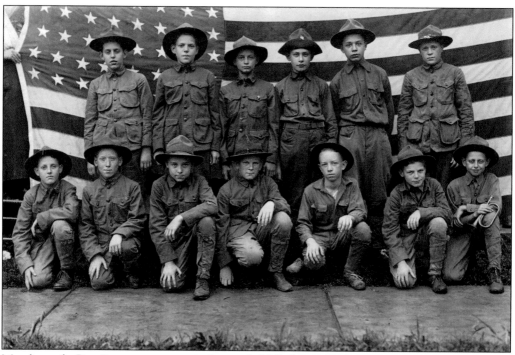

Members of a Boy Scout troop pose in front of a U.S. flag in 1919.

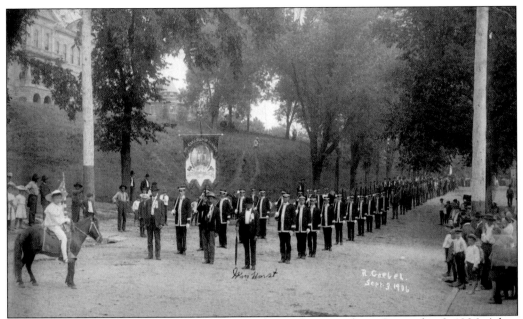

Modern Woodsmen line up in front of the courthouse for a parade on September 3, 1906. A boy on horseback stands in front of the woodsmen, while parade watchers gather for the event.

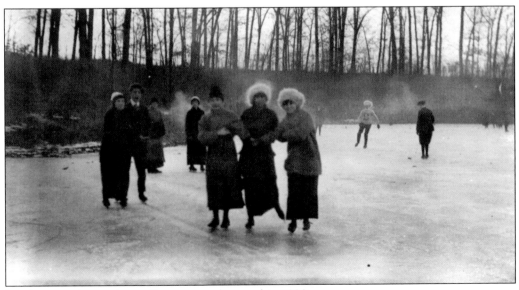

Ice-skaters enjoy a winter afternoon at the pond in 1920.

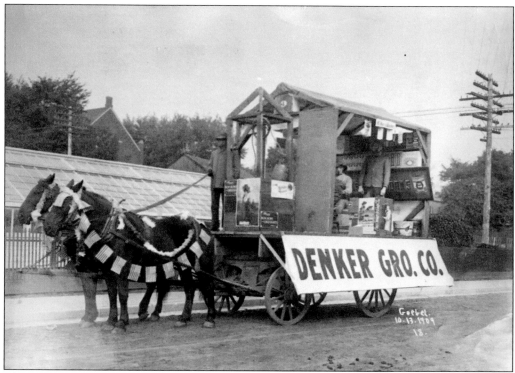

The St. Charles centennial was celebrated in October 1909 and featured a horse-drawn float advertising the Denker Grocery Company.

A crowd waits for a parade to come by Second and Jefferson Streets in 1900.

Two trees joined by a single branch were dubbed "St. Charles Siamese Twins" in about 1856. A gentleman relaxes by one of the trees.

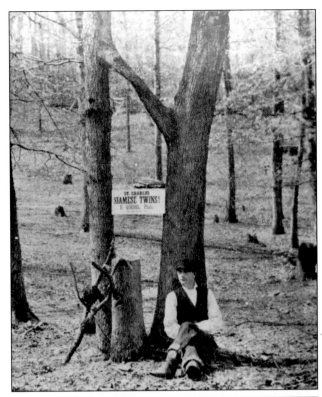

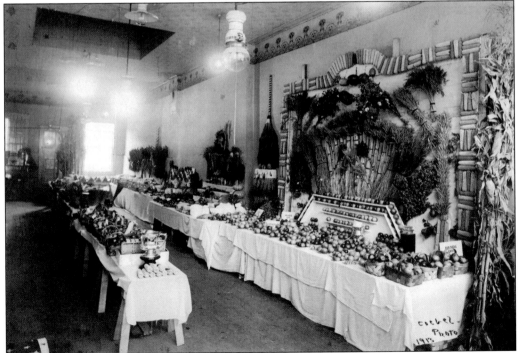

The St. Charles County Produce and Poultry Show was held in 1913 in the Rechtern and Becker building at the corner of Main and Madison Streets.

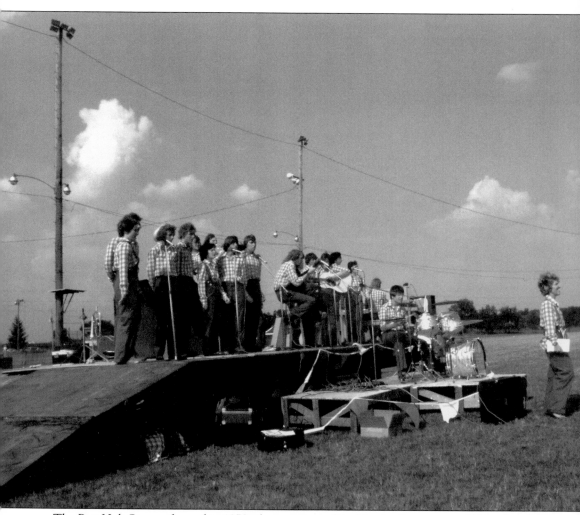

The Patt Holt Singers formed in 1972 when a group of St. Charles Borromeo middle school music students and their teacher, Patt Holt, decided to continue their choir class into the summer break. Soon the group was performing for county fairs and other events in St. Charles, St. Louis, and beyond. Today the Patt Holt Singers are a professional show group that has performed for five American presidents and in over 26 foreign countries. Holt and her singers are shown here performing for a small St. Charles event during their early years. (Author's collection.)

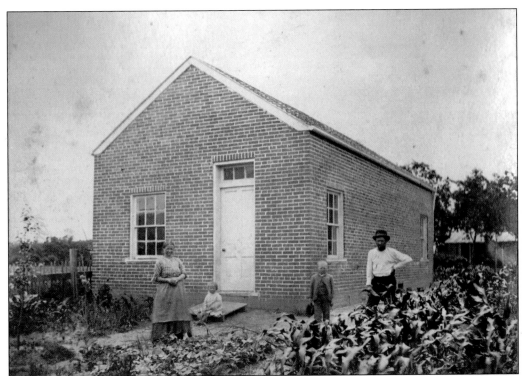

A redbrick house with a vegetable garden in the front yard is home to this family in the 1800s.

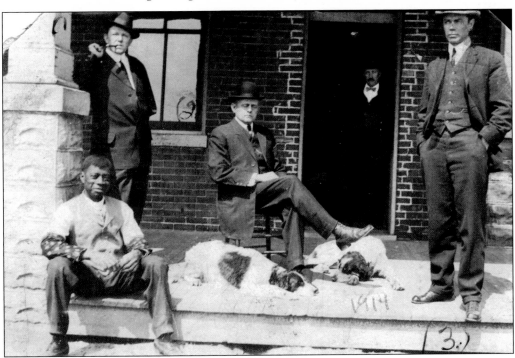

Five men relax on the porch with their dogs at the front door of the St. Charles Boat Club on Monroe Street in 1914.

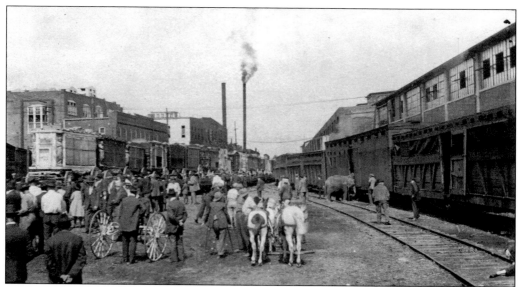

A circus unloads railcars in St. Charles in 1930. ACF is seen in the background.

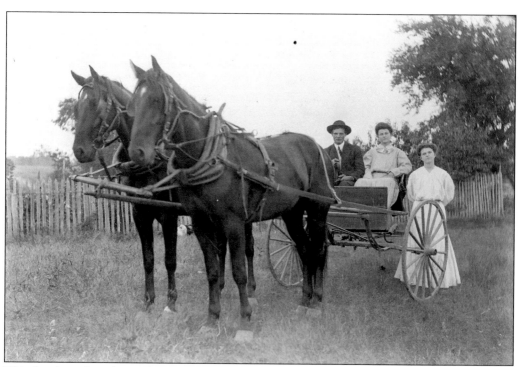

This family with its horse-drawn cart is likely one of the earliest families to have settled in the St. Charles area.

Nora Morton and Ann Frigner stand in front of Iffrig's Store at 816 Adams Street. At the time, the ladies lived at 827 Adams Street.

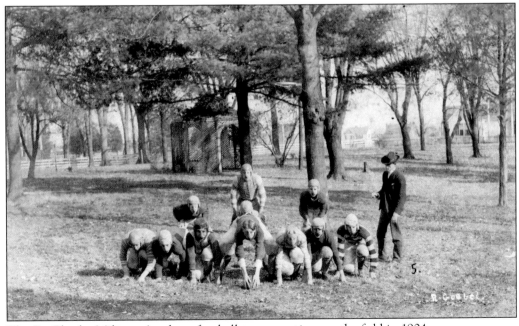

The St. Charles Military Academy football team practices on the field in 1904.

Blanchette Park, pictured here in 1960, was established in 1914. The park was named in honor of Louis Blanchette, the founder of St. Charles in 1769.

A woman stands behind the gate of her St. Charles home in the 1800s.

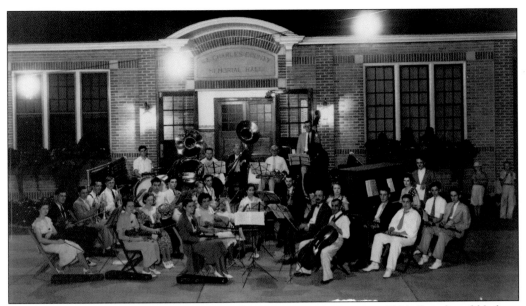

The St. Charles Community Orchestra performs a summer concert in 1934. Standing fifth from the right is Prof. Edward A. Schubert, the director. Other orchestra members include Sterling Zumwalt, Edward Barklage, William Briscoe, and Clarence "Pete" Decker. In 1934, the orchestra alternated concerts with the St. Charles Municipal Band on Thursdays at Blanchette Park. Because of the small band shell, the orchestra held its concerts in front of Memorial Hall.

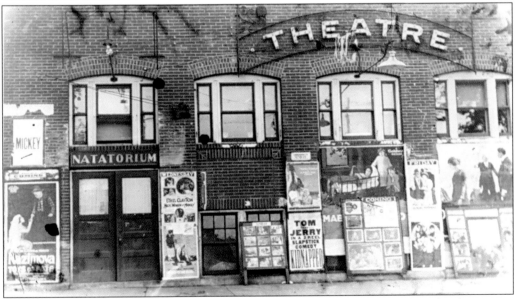

In 1918, the Strand Theater was located on Second Street in St. Charles. When the theater was remodeled, the top story was removed, and a swimming pool was added. The building operated as a pool during the summer and a theater during the winter, as indicated by the theater and natatorium signs in the photograph. Posters on the front of the theater promote silent movies. The Strand later became St. Charles Cinema. This picture was found in 1918 by Ed Herman, who operated the silent picture machine in the building at that time. Herman later donated the picture to the St. Charles County Historical Society.

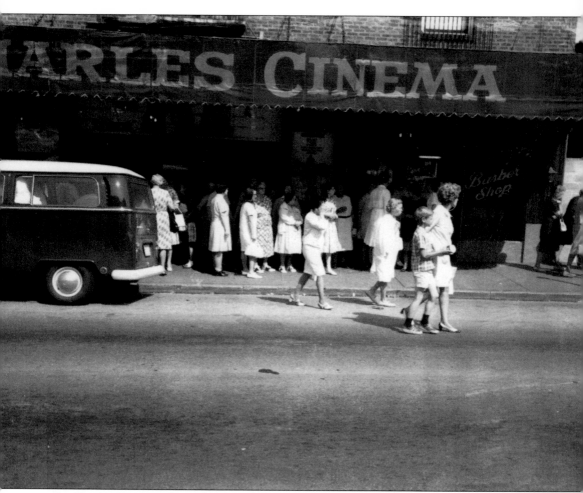

St. Charles Cinema, shown here in 1970, was once the Strand Theater. The marquis under the St. Charles Cinema awning advertises the movies *Camelot* and *The Longest Day*. The theater building was later torn down to build a new city hall.

Eight

DISASTER STRIKES

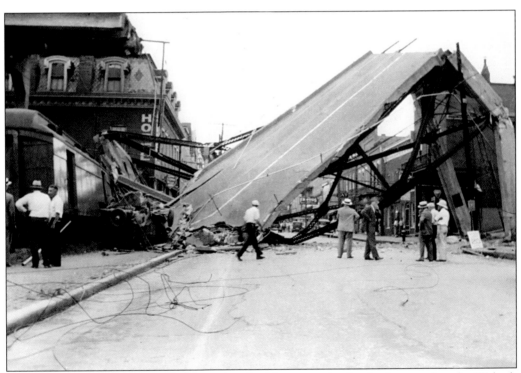

On June 26, 1935, several railroad cars detached from a train that had stopped at the Wabash station. The runaway cars struck some highway bridge supports as well as the Galt Hotel. A 40-foot span of the Highway 115 bridge fell onto Main Street. There were no fatalities.

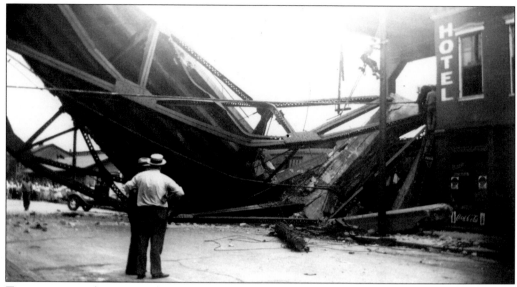

Two men assess damage to the Highway 115 bridge and Galt Hotel after the 1935 accident.

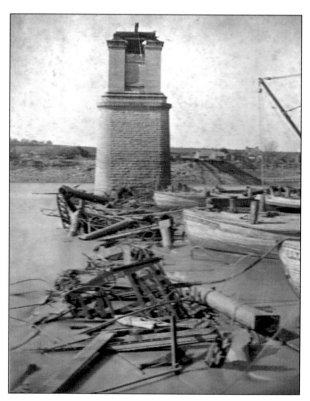

A railroad bridge accident occurred on November 8, 1879, when some cars derailed and fell from the Wabash Bridge near Fourth Street in St. Charles. At least one of the cars carried live hogs, but apparently a few of the hogs survived the fall and were later found grazing.

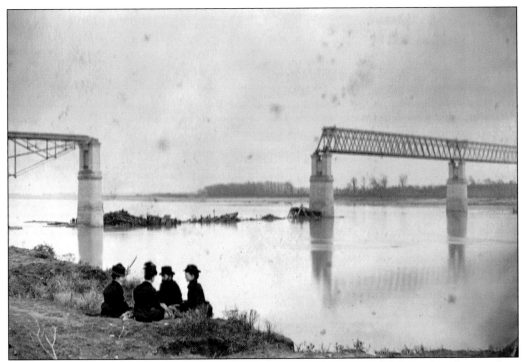

A group of visitors, looking northeast, views the bridge damage and debris after the accident in 1879.

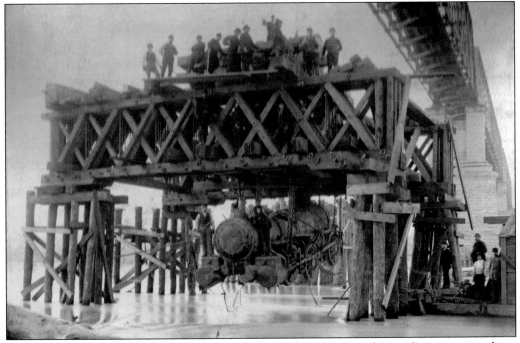

After another Wabash Railroad Bridge accident in 1881, the Grand Mogul's engine, weighing 70 tons, lay at the bottom of the river for almost a year before being raised to the surface. Engineer John Kirby was killed in the accident.

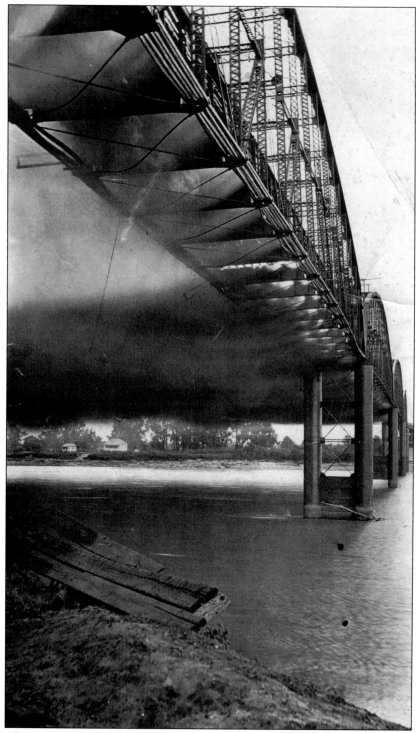

On September 26, 1916, a fire caused between $150,000 and $200,000 damage to the floor of the Highway 115 bridge. Pigeons had built nests under the bridge, and sparks from a passing train ignited them.

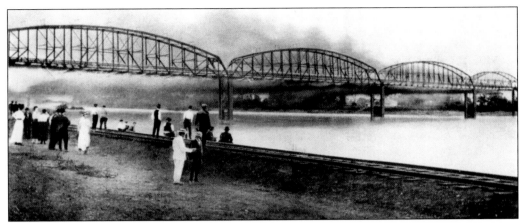

Spectators on shore watch the bridge fire in 1916.

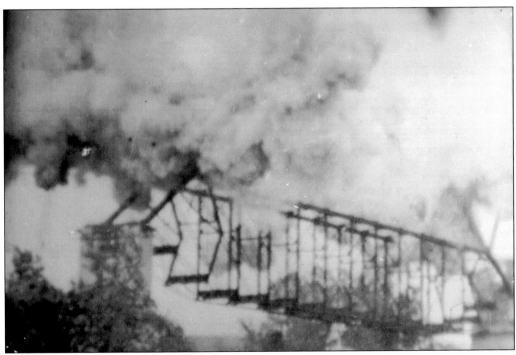

The old Wabash Bridge is demolished in 1937, after a newer bridge was built to handle heavier, faster railroad traffic.

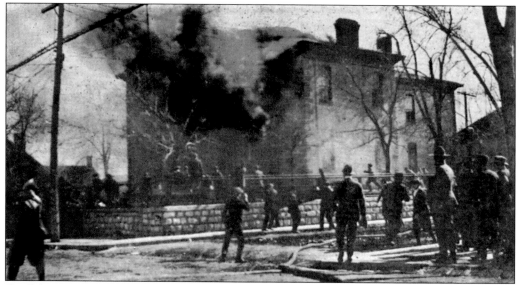

On February 14, 1918, St. Charles High School at Fourth and Jefferson Streets caught fire and sustained significant damage. The high school was later moved to the site of what had been the St. Charles Military Academy.

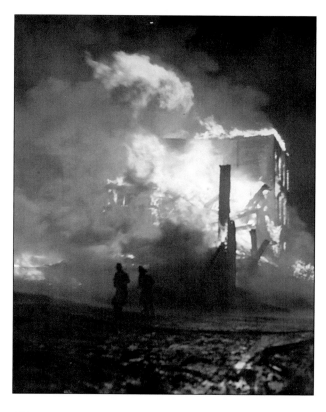

The Null Grain Mill at Fourth and Clay Streets caught fire on November 30, 1958.

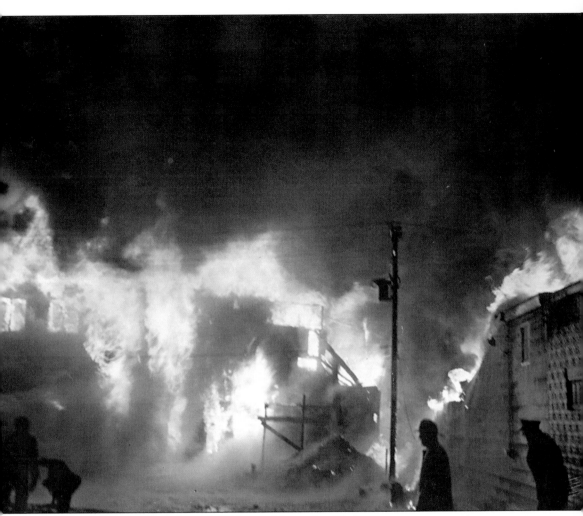

Firefighters wrestle the Null Grain Mill fire on November 30, 1958.

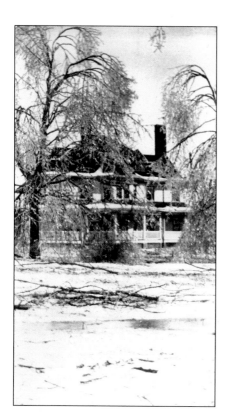

An ice storm in 1900 hampered activity at Lindenwood College and elsewhere in St. Charles.

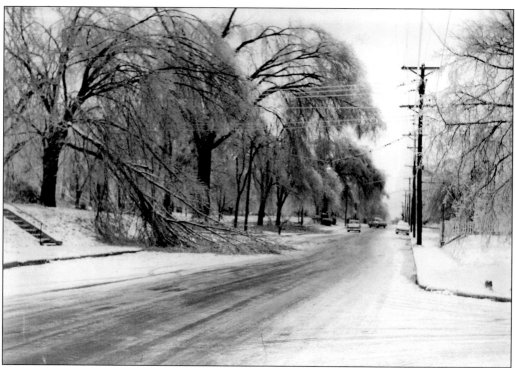

In 1960, another ice storm bent and broke the branches of trees along the street.

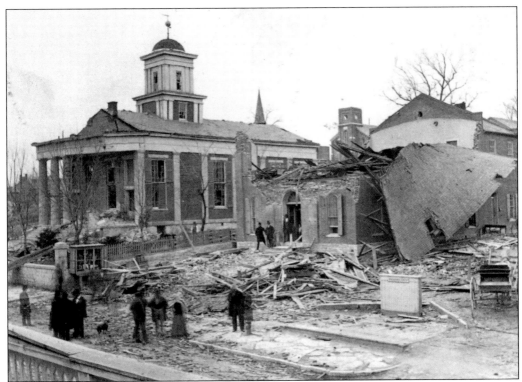

St. Charles Savings Bank was badly damaged during the tornado of February 1876. Theodore Bruere, the bank's first president, quickly opened in another location.

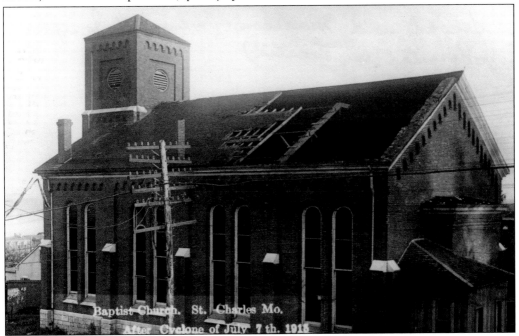

First Baptist Church at Second and Madison Streets undergoes repairs after the tornado on July 7, 1915.

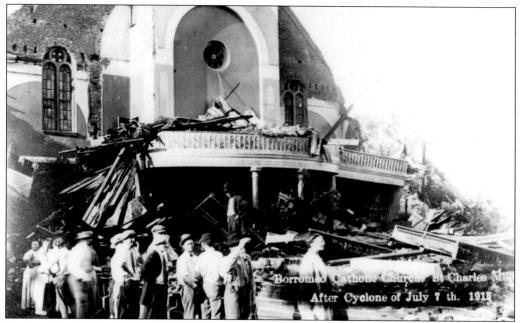

Much of St. Charles Borromeo Church was destroyed by the July 7, 1915, tornado.

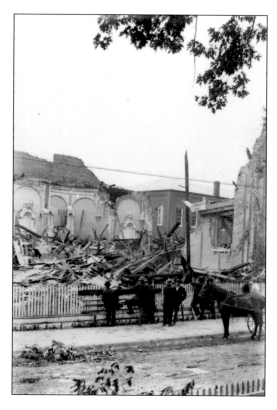

People began arriving to see the wreckage of St. Charles Borromeo Church about an hour after the storm had ended in 1915.

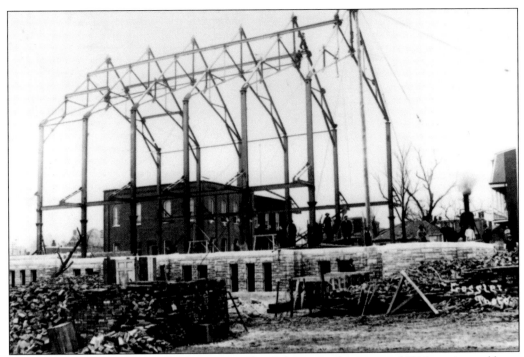

The rebuilding of the St. Charles Borromeo Church began in the winter of 1915, as pictured here, and the church was completed and ready to be blessed by the archbishop on May 27, 1917.

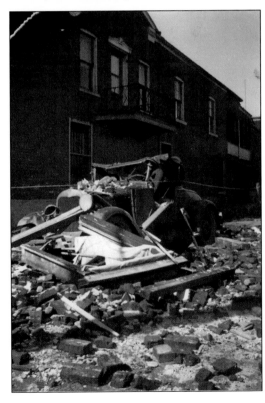

The damage to this automobile was caused by the tornado that wreaked havoc in St. Charles on March 29, 1938.

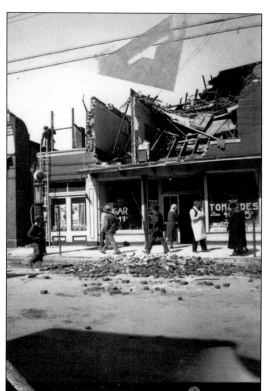

Damage to roofs and storefronts from the March 29, 1938, tornado is evident in this photograph.

Taken in front of Schibi's Tavern on Second Street, this photograph shows yet more damage caused by the storm on March 29, 1938.

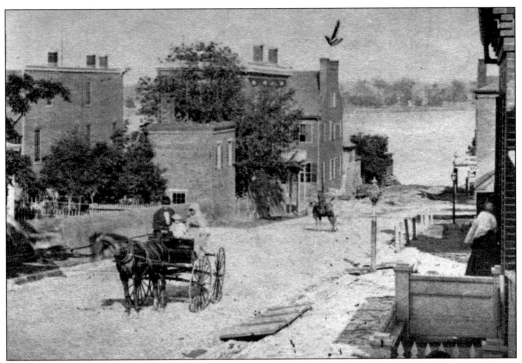

The rising Missouri River threatens to flood in about 1877. This view is from Jefferson Street between Main and Second Streets.

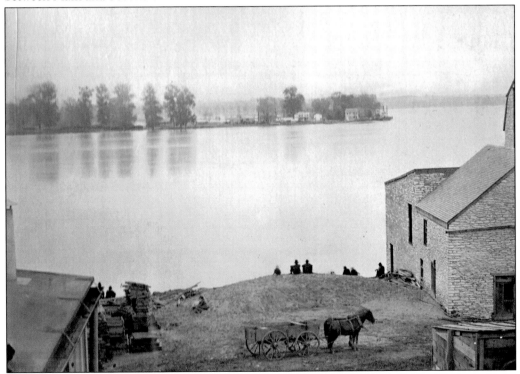

Some men sit on the bank facing the flooded Missouri River in 1881.

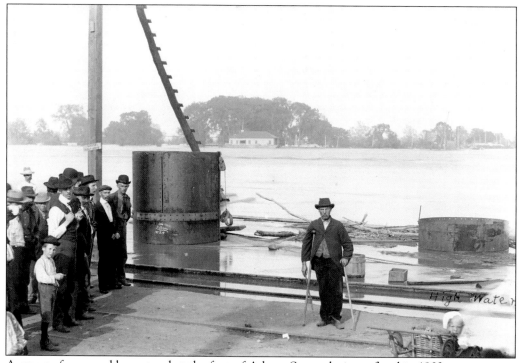

A group of men and boys stand at the foot of Adams Street during a flood in 1903.

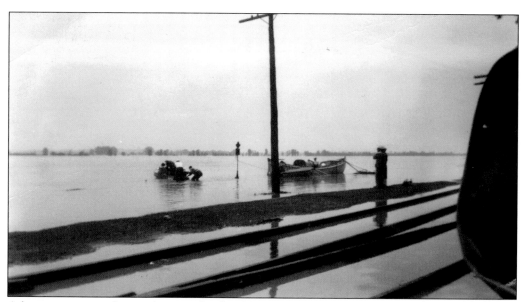

A boat rescue is underway during a flood in May 1943.

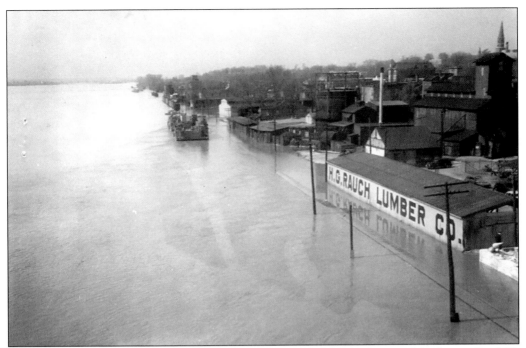

The Missouri River is still rising in this picture, taken from the Highway 115 bridge on April 29, 1944. H. G. Rauch Lumber Company is partly underwater.

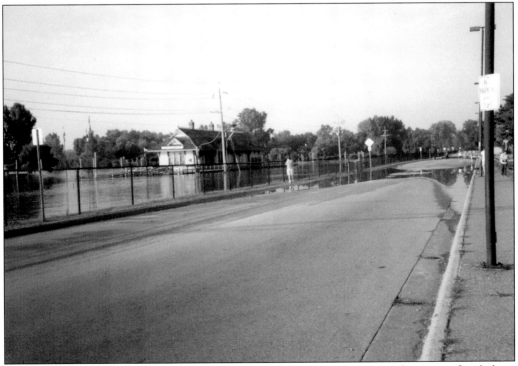

Frontier Park and the Missouri-Kansas-Texas Railroad (Katy) station depot are flooded on July 17, 1993.

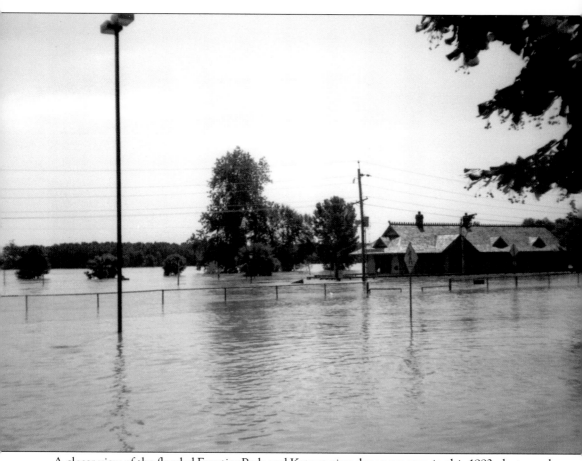

A closer view of the flooded Frontier Park and Katy station depot are seen in this 1993 photograph.

Nine

MAIN STREET, U.S.A.

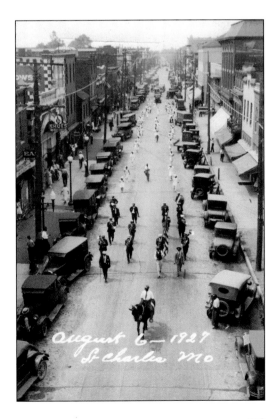

The Relief Association parade took place on Main Street on August 6, 1927. The first man on horseback is Byrd Washington. The Relief Association was formed in 1911 by the St. John's AME (African Methodist Episcopal) Church to aid the poor in the African American community.

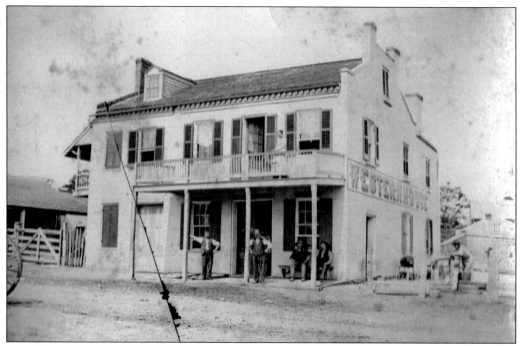

The Western House at Main Street and Boone's Lick Road was built prior to 1821 and served as a hostelry and inn. It originally included a blacksmith shop. The building is now used commercially.

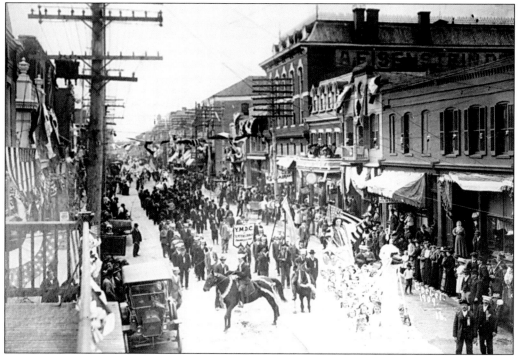

St. Charles centennial parade in October 1909 featured marching bands, horses, and cars. A parade queen reigns at the top of a float.

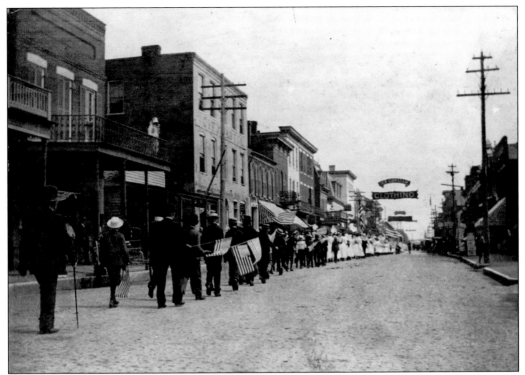

Dr. C. M. Johnson leads the Civil War veterans' parade down Main Street in about 1900.

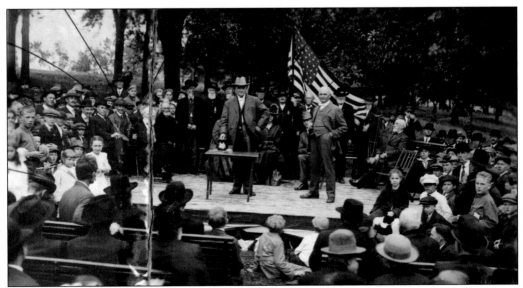

Civil War veterans and members of the GAR attend a Civil War veterans' tribute on Main Street in 1900.

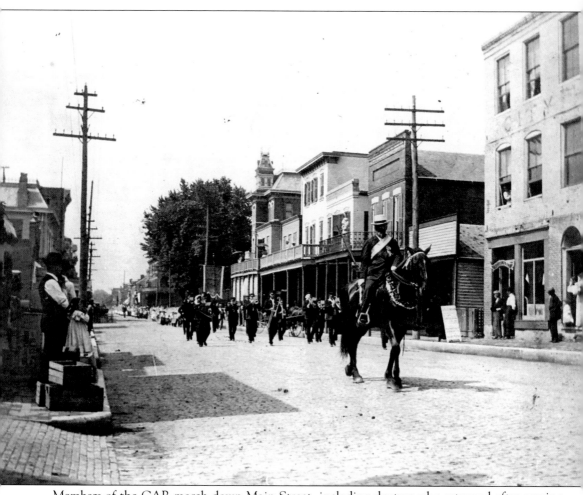

Members of the GAR march down Main Street, including doctors who returned after serving in the Civil War. Dr. C. M. Johnson, who was held prisoner during the war, leads on horseback. St. Charles Hotel can be seen from this view, as well as Old Pup Saloon, Tainter Drug, Denker's, Broeker's, and Meyer Jewelry Store.

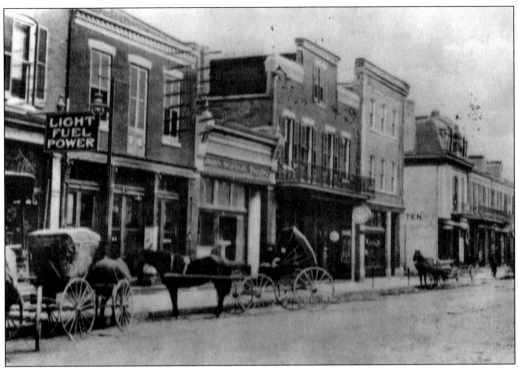

St. Charles Lighting Company was located on Main Street in 1909.

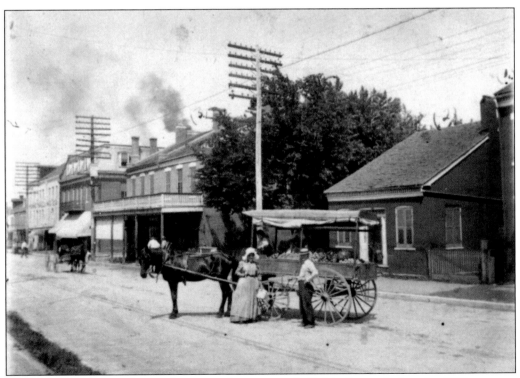

This photograph provides another view of an uncrowded Main Street during the 1880s.

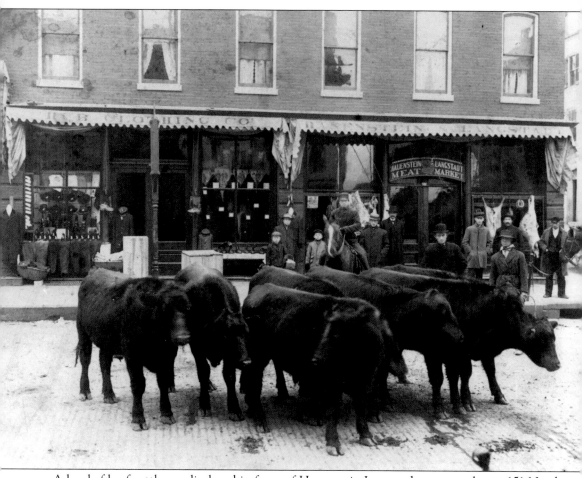

A herd of beef cattle are displayed in front of Hauenstein-Langstadt meat market at 151 North Main Street in about 1911. The cattle, raised by Edward Boschert, were sold to the market.

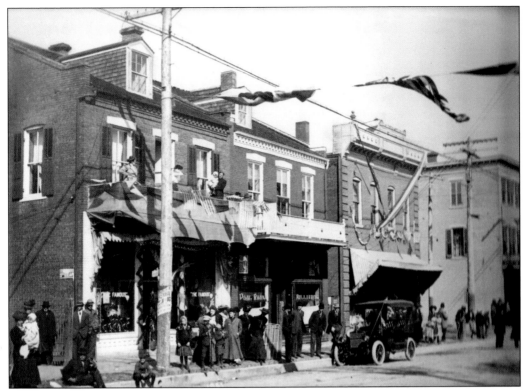

Another parade takes place on Main Street on October 11, 1901.

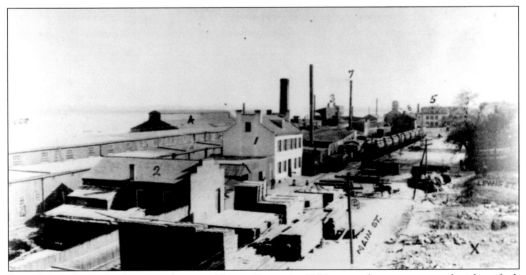

From Main Street looking south toward Lewis Street in 1878, several structures can be identified, including the priest house at St. Charles Borromeo Church (1); the boys' school (2); the roller mill (3); the blacksmith shop and St. Charles Car Company (4); and the Galt Hotel (5).

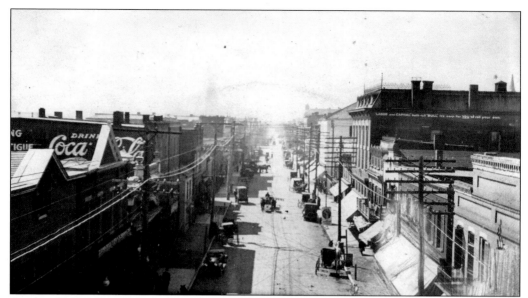

A view of Main Street is seen here in the 1920s, looking south from the Highway 115 bridge.

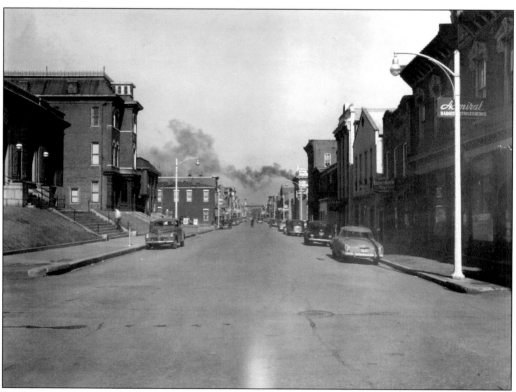

Looking north on Main Street, the old post office is the first building on the left. It was built in 1909.

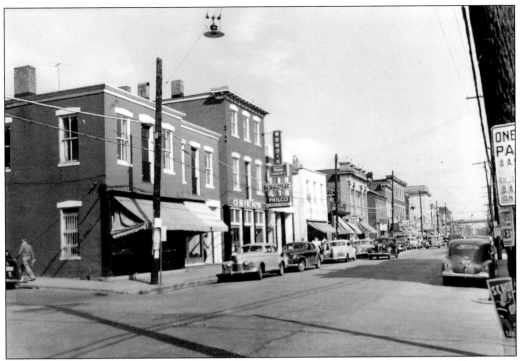

Main Street was beginning to become a busy place for retailers and other types of businesses by 1960.

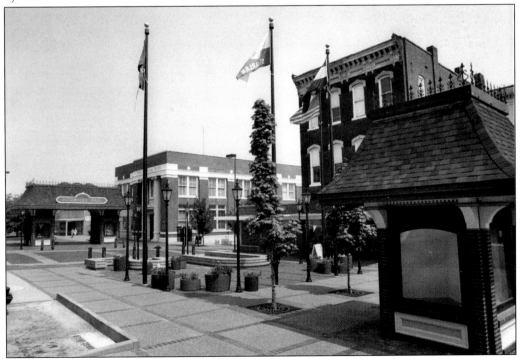

The Main Street Riverside Mall is pictured here in August 1983. The new look was not appealing to many visitors, and Main Street was later restored to resemble an earlier time in its history.

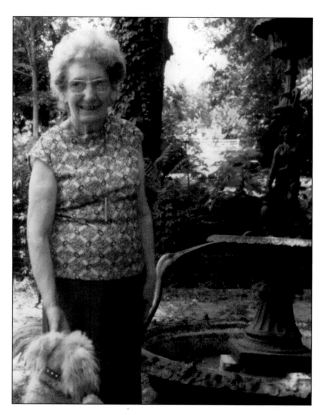

Virginia Musterman Tschudin was one of the first antique dealers and shop owners to buy property and establish a business on Main Street during the early restoration of the historic district. She was dubbed the "first lady of South Main" in recognition of her contribution. The fountain in this photograph once stood in front of the Civil War Museum in Alton, Illinois. (Courtesy of Barbara Musterman.)

During the 1970s, the building at 519 South Main Street was the House of Yesterday, an antique shop and residence owned by Tschudin. The poem in the introduction to this book, "Greetings from Old South Main," was penned by Tschudin during this time.

Ten

ST. CHARLES TODAY

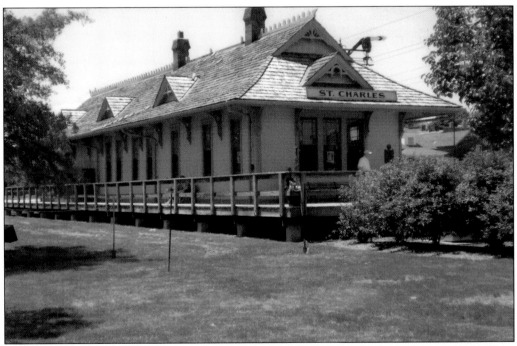

Missouri-Kansas-Texas (MKT) Railroad depot in St. Charles is today better known as the Katy (K-T) depot. The first MKT train passed through St. Charles on April 1, 1894. One of the largest station and mail robberies in United States history occurred here in 1921, when over $110,000 was stolen from a U.S. mail messenger at the depot. When the railroad stopped operating its route from St. Charles County to Sedalia in 1986, the Katy Trail State Park was developed. It is built on the former corridor of the railroad and offers 225 miles of trail for hiking and biking from St. Charles to Clinton. The Katy Trail is now part of the Missouri state park system. The depot was restored in 1978, and the platform is open to visitors. (Author's collection.)

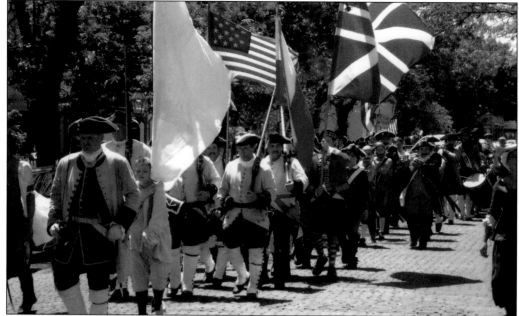

The Lewis and Clark Fife and Drum Corps marches down Main Street in May 2008 to the delight of spectators. Since 1979, Lewis and Clark Heritage Days have been celebrated each May in Frontier Park along the Missouri River to mark the anniversary of the expedition's arrival in St. Charles in May 1804. The event features a grand parade, military encampment, crafters, reenactors, musket and cannon demonstrations, and period music. (Author's collection.)

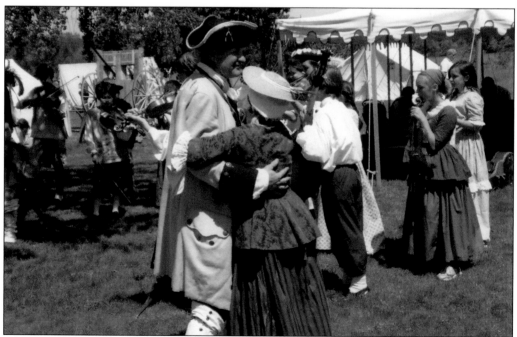

A couple dressed in period clothing dances to music performed by fiddlers and other local musicians at the 2008 Lewis and Clark Heritage Days celebration. (Author's collection.)

On May 14, 1804, William Clark and his crew landed on the bank of the Missouri River in St. Charles and waited for Capt. Meriwether Lewis and others to join them. "This village is about one mile in length," Clark wrote, "and about 450 [inhabitants] chiefly French, those people appear [poor], polite & harmonious." On May 21, the expedition left St. Charles to embark on what would become one of the greatest American adventure stories ever told. A 15-foot-tall statue of Lewis and Clark and their dog Seaman, designed by artist Pat Kennedy, was installed in April 2003 at Frontier Park near the site where the explorers landed nearly 199 years before. (Author's collection.)

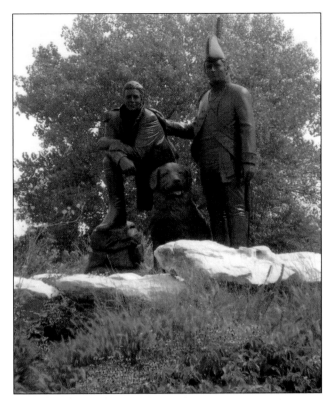

St. Charles is a progressive city with strong ties to its colorful past. (Author's collection.)

BIBLIOGRAPHY

Beckmann, Ray. "Friends I Have Known: Virginia Musterman Tschudin." *Historic Main Street*, Vol. 1, No. 3. April, May, June 2006, 8–9.

Brown, Jo Ann. *St. Charles Borromeo, 200 Years of Faith*. St. Louis, MO: The Patrice Press, 1991.

Buse, John J. *In His Own Hand, A Historical Scrapbook of St. Charles County, Missouri*. St. Charles, MO: Scholin Brothers Printing Company, Inc., 1998.

Ehlmann, Steve. *Crossroads, A History of St. Charles County, Missouri*. St. Charles, MO: Lindenwood University Press, 2004.

Glaser, Janet. *I Remember When . . . , A Pictorial History of the St. Charles, Missouri Area*. Dallas, TX: Curtis Media Corporation, 1990.

Olson, Edna McElhiney. *Historical Saint Charles, Missouri*. St. Charles, MO: St. Charles County Historical Society, 1967.

Scott, Archie. "The Old Katy Depot." *Historic Main Street*, Vol. 1, No. 3. April, May, June 2006, 4–7.

St. Charles County Heritage, Volume 26, No. 2. St. Charles, MO: St. Charles County Historical Society, April 2008.

St. Charles County Heritage, Volume 26, No. 3. St. Charles, MO: St. Charles County Historical Society, July 2008.

Tschudin, Virginia M. "Greetings From Old South Main." *Poems Through the Years*. St. Charles, MO: Self-published, 1980.

About St. Charles County Historical Society

The St. Charles County Historical Society was founded in 1956, incorporated in 1958, and is dedicated to the preservation of documents and artifacts related to St. Charles County history. The society preserves primary and secondary source materials relating to the county, publishes a monthly newsletter and a quarterly publication called *St. Charles County Heritage*, and sponsors various activities to promote the preservation and study of history.

The historical society is located at 101 South Main Street in St. Charles in a house built over 185 years ago. The building was originally known as the Market and Fish House and contained booths for produce, a scale to weigh wagonloads of goods, outside oil lamps, and a public bulletin board. The town band often played on the market steps to entertain people who sat on nearby benches while waiting for the mail coach to arrive at the post office.

The building lost its roof in the tornado of 1876 and was later replaced. In 1886, the building became the St. Charles City Hall (as indicated by the lettering that still appears above the front door). A new city hall was built in 1973, and the building at 101 South Main Street was placed on the National Register of Historic Places on November 14, 1980. It became the home for the St. Charles County Historical Society in July 1982.

DISCOVER THOUSANDS OF LOCAL HISTORY BOOKS FEATURING MILLIONS OF VINTAGE IMAGES

Arcadia Publishing, the leading local history publisher in the United States, is committed to making history accessible and meaningful through publishing books that celebrate and preserve the heritage of America's people and places.

Find more books like this at
www.arcadiapublishing.com

Search for your hometown history, your old stomping grounds, and even your favorite sports team.

Consistent with our mission to preserve history on a local level, this book was printed in South Carolina on American-made paper and manufactured entirely in the United States. Products carrying the accredited Forest Stewardship Council (FSC) label are printed on 100 percent FSC-certified paper.

MADE IN THE USA